POSTCARD HISTORY SERIES

McDowell County
Coal and Rail

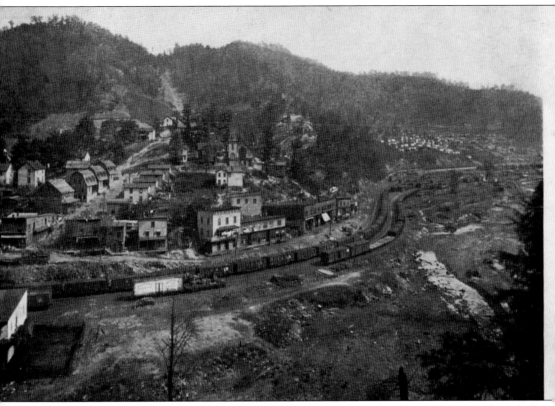

This overall general view is of the Norfolk & Western rail yard in the east portion of Kimball, West Virginia, around 1899. Kimball originally was named East and West Vivian. The mainline of the Norfolk & Western Railroad ran through Kimball, before the railroad built a tunnel behind the town. The town of Kimball was established along the Elkhorn Creek and is five miles from Welch, West Virginia. (Courtesy of the Huger Collection.)

ON THE COVER: This 1930s view is the Carswell Mine of the Koppers Coal Company, located two miles from Kimball, West Virginia. The mine generated its own electric power for operation and for the community. The powerhouse is to the right in this postcard, next to the smokestack. This coal tipple had six loadout tracks for various sizes of coal to be loaded on railroad hoppers. The operation was shutdown in 1953. (Courtesy of the Huger Collection.)

POSTCARD HISTORY SERIES

McDowell County Coal and Rail

Jay Chatman

ARCADIA
PUBLISHING

Published by Arcadia Publishing
Charleston, South Carolina

Printed in the United States of America

Library of Congress Control Number: 2013953952

For all general information contact Arcadia Publishing at:
Telephone 843-853-2070
Fax 843-853-0044
E-mail sales@arcadiapublishing.com
For customer service and orders:
Toll-Free 1-888-313-2665

Visit us on the Internet at www.arcadiapublishing.com

To the coal miners and their families for their perseverance, hard work, and dedication in the production of coal throughout the years

CONTENTS

ACKNOWLEDGMENTS

This Postcard History Series book is my first with Arcadia Publishing. Unless otherwise noted, all images shown here are from the Huger Collection, which includes thousands of coal-mining and railroad artifacts. I have accumulated this collection for over 40 years. Several others helped in making of this book. I wish to thank Geneva Steele, Sammy Frost, Bob McGovern, and Lacy Wright Jr. for supplying their postcard images.

INTRODUCTION

McDowell County, West Virginia, truly was at the center of the great Pocahontas coalfield. It was formed from Tazewell County, Virginia, in 1858 and named for Gov. James McDowell of Virginia. In 1863, McDowell County, along with 54 other counties in Virginia, broke away and created the state of West Virginia.

McDowell County was destined to be known around the world, because of its rich coal deposits found here. Coal was first discovered In Tazewell County, Virginia, in 1750 by Dr. Thomas Walker, a physician and surveyor from Albermarle County, Virginia. It took 130 years for coal to be explored or mined in the area. In the early 1880s, coal was being used for local home heating and blacksmithing. In Virginia, the Norfolk & Western Railway extended the railroad down the New River to Bluefield, West Virginia, to reach the coal seams in Pocahontas, Virginia. Once that was established, the decision was made to bore through the mountain to create the Coaldale Tunnel into McDowell County from Mercer County, West Virginia. This became the Ohio extension of the railway following Elkhorn Creek to the Tug River at Welch, West Virginia. There were over 100 mining operations that opened in McDowell County, such as Northfork Angle Colliery, Mill Creek Coal and Coke Company, Shamokin Coal and Coke Company, Elkhorn Coal and Coke Company, Coaldale Coal and Coke Company, Crozer Coal and Coke Company, United States Coal and Coke Company, Solvay Colleries, Central Pocahontas Coal Company, and Fordson Coal Company. The mining of coal has been a factor in the advancement of living conditions as a part of the Industrial Revolution in remote areas. Inventors developing new mining practices and mining machines changed the course of history. Among them were railroad steam engines, steamboats, and steamships.

If quality and quantity are considered, the coalfield area, which includes McDowell County from its inception, was the greatest coalfield in the world. It is difficult to imagine the quantity of coal that was beneath the surface of McDowell County. People who used coal learned that some of the purest coal in the world came from McDowell County. Coal from McDowell County's mines was sold too many states and in many foreign countries. Coal was not only used as a fuel, but also as an important source of chemicals for industry and everyday needs.

McDowell County has an area of 533 square miles, and the population in 1930 was 90,479. In the 1930s, the county was the banner coal-producing county of the state of West Virginia and, for many years, led the nation in the production of the famous Pocahontas Smokeless Coal. It was exceptional for making coke, the residue of coal left after destructive distillation that was used as fuel, and other by-products. McDowell County, between 1930 and 1940, had 28 workable seams. For many early years, the county's output averaged from 20 million to 26

million tons of "smokeless coal" a year, bringing the highest prices on the market. Up until 1932, McDowell County had produced a total of 528,094,573 tons of coal and, at that time, had a reserve of 4,812,503,433 tons, according to the West Virginia Department of Mines. It was estimated that the coal reserves were sufficient to last from 75 to 100 years. Some of the large interests in McDowell County were the Koppers Company, Ford Automotive Company, United States Coal and Coke Company (a subsidiary of United States Steel Corporation), Consolidated Coal Company, and Berwind-White Coal Mining Company.

There were more than 20,000 employees in the mines in McDowell County, and the average monthly payroll in the 1930s was $2 million, totaling approximately $25 million a year. The miners lived in modern homes and had electric lights, electric washing machines, and other appliances. After World War II, almost everyone had an automobile. Living conditions were rated higher in McDowell County than in any other coalfield in the state. Many of the men were steadily employed by the same coal company for 25 to 40 years. A lot of the mining companies were engaged extensively in welfare work, directing their efforts toward better housing, adequate school facilities, recreational advantages, and health. Accident prevention was featured, and remarkable safety records were set up in some of the coal mines. The government's unemployment census in 1930 showed only 549 coal miners, or .6 of 1 percent of the population, were out of a job in McDowell County. This was half the state's average of 1.2 percent. The county seat of Welch was the natural shopping center for the county.

Because of topographical conditions (the area was surrounded by mountains), factory sites were limited. Therefore, Welch itself cannot be classified as industrial, although McDowell County ranked as one of the state's leading industrial counties. The headquarters for American Coal Cleaning Corporation, owned by Col. Edward O'Toole, which installed coal-cleaning plants throughout the world, is located in Welch, West Virginia. McDowell County had three Chicago packing companies' warehouses and many manufacturers of nationally advertised goods had distributors all located in the county seat of Welch.

In the 1930s and 1940s, Welch net sales aggregate was about 6 million dollars annually. The Welch division of Appalachian Electric Power Company had consistently led 43 divisions in nine states in sales of electric ranges and electric refrigerators and, in one month, exceeded its electric range quota by 620 per cent and refrigerator quota by 340 percent. One local Welch business sold more than 8,000 electric washing machines during a five-year period. A survey in the 1940s showed 85 percent of homes just in Welch had electric ranges and 94 percent used electric appliances. Welch had a population of 6,264, and other towns like Northfork had 387, Keystone had 800, Kimball had 1,580, Davy had 900, Iaeger had 986, Gary had 1,325, Anawalt had 1,366, and War had 1,277, according to the 1940 census. There were 55 mining operations in McDowell County between 1930 and 1940.

Growing up in McDowell County during the 1950s and 1960s was a rewarding experience. Residents knew everyone in all the neighborhoods and treated each other like the members of one big family, depending upon each other when they were needed. One could not have asked for a better environment for growing up than McDowell County's coal communities, and there was a caring attitude unlike anywhere else. I hope you enjoy this postcard history book and see what McDowell County was like in its glory years.

One

Mining Communities and Towns

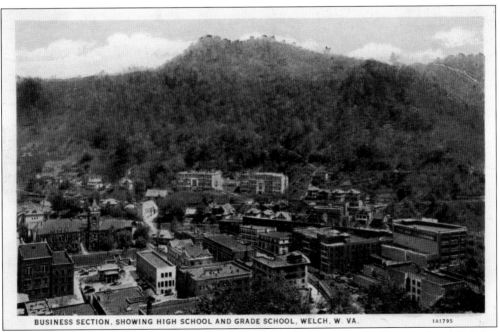

BUSINESS SECTION, SHOWING HIGH SCHOOL AND GRADE SCHOOL, WELCH, W. VA. 1A1795

This October 1931 postcard image shows an overall view of the business section of Welch, West Virginia. In the background on the hill is the Welch High School and Welch Graded School. Also, in the left-hand corner can be seen the McDowell County Courthouse. In 1892, the county seat was established in Welch, situated on the Norfolk & Western Railroad.

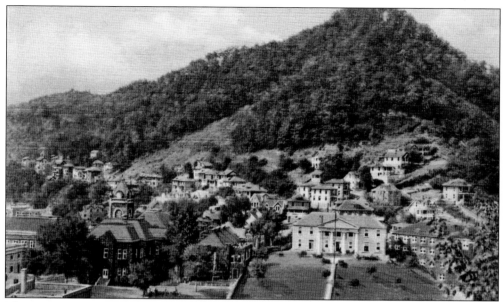

This is an early view of the McDowell County Courthouse, the jail, and the first world war memorial building in the United States. The memorial building was erected in 1920 to honor soldiers from World War I. The memorial building was originally the Welch High School, before it was redesigned by Hassel T. Hicks. Most construction of buildings and houses were on the mountain sides, because level land was a scarce commodity.

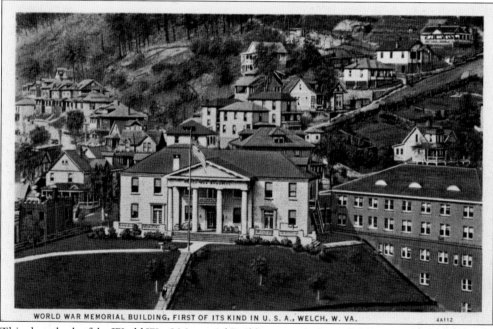

WORLD WAR MEMORIAL BUILDING, FIRST OF ITS KIND IN U. S. A., WELCH, W. VA. 4A112

This closer look of the World War I Memorial Building reveals the well-kept surrounding grounds. Civic, city, and county organizations utilized the structure for meetings, socials, dinners, and dances. The top floor was where they would have many dances. The author, while attending Welch High School in the 1960s, went to many of these dances, which were usually held on Friday nights after a football game.

"Greetings from Welch, W. Va." is typical of an early postcard, showing an area in a generic setting that would have been used for many towns and communities across the United States. This image shows Welch as a farming area, with a barn and a haystack. This could have been a drawing or an artist's painted rendering of an area.

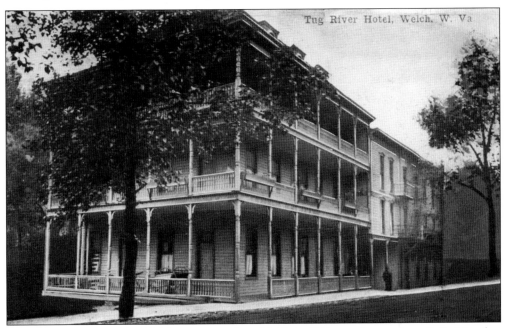

Tug River Hotel, Welch, W. Va

The Tug River Hotel in Welch was erected on McDowell Street about where G.C. Murphys was later built. The fire of 1911 in Welch destroyed most of the wood buildings in town except for the McDowell National Bank, the courthouse, and a few other structures. In its day, the Tug River Hotel looks like a great place to have stayed for the night.

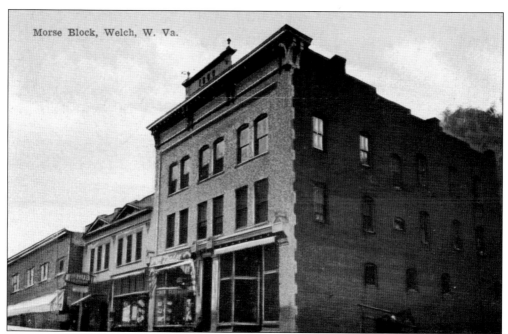

This row of buildings makes up the Morse Block in Welch. Several businesses are located here, such as the Leader Clothing Store and the Hub Clothing Store. Clothes sold here were some of the finest anywhere. Salesman would travel by passenger train from Philadelphia, New York, Cincinnati, and Chicago to present their wares. The date on this postcard is January 7, 1911.

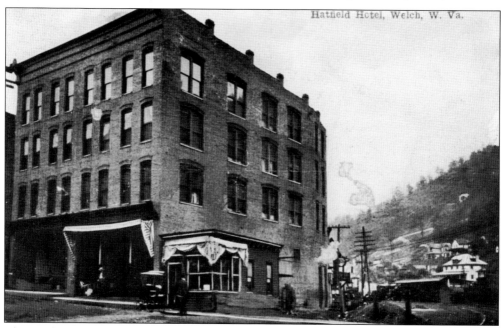

The Hatfield Hotel was located in Welch on Wyoming Street and on the Norfolk & Western Railroad mainline through town. Just past the hotel to the left, is where the railroad passenger station sits. It was an easy trek to the hotel for people staying overnight. This image dates between 1912 and 1915. The Elwood Hotel was later built in this location.

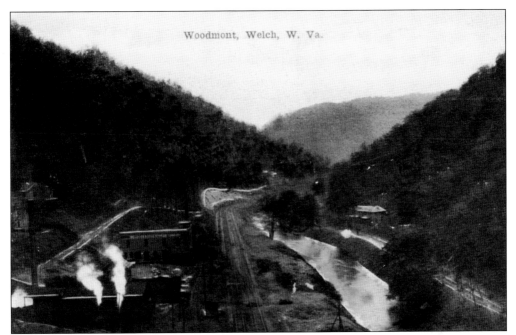

This c. 1910 image shows the Woodmont section of Welch. The road to the right side is Virginia Avenue, located along Elkhorn Creek. The Norfolk & Western mainline is in the center. The area to the left on the mountainside later became Court Street, Beech Street, Oak Street, and Linden Street. Dozens of homes were built here, along with a school.

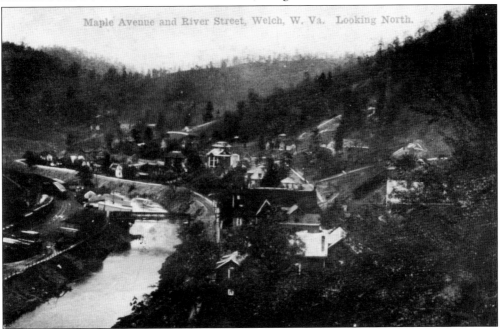

The view of this early 1900s postcard image of Maple Avenue and River Street in Welch looks north. Shown in the right middle is the First Methodist Church. River Street later was changed to Virginia Avenue. The left side shows several businesses and part of the Norfolk & Western passenger station.

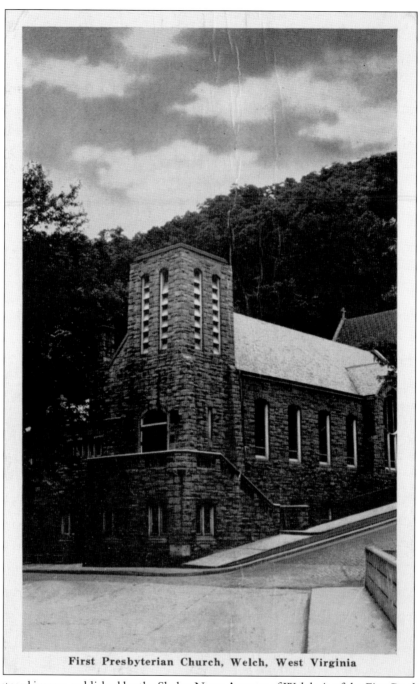

First Presbyterian Church, Welch, West Virginia

This postcard image, published by the Sledge News Agency of Welch, is of the First Presbyterian Church. The stone church sits on Virginia Avenue across from the Welch City Hall, and the street to the right leads up to Maple Avenue, where various homes and the Welch Junior High School and Welch High Schools were built. The Boy Scouts had meetings in the basement in the late 1950s and early 1960s. The Methodist church, the Episcopal church, and the Catholic church were located across from each other. The First Presbyterian Church was organized December 5, 1897, and the first pastor was Rev. J.C. Wool.

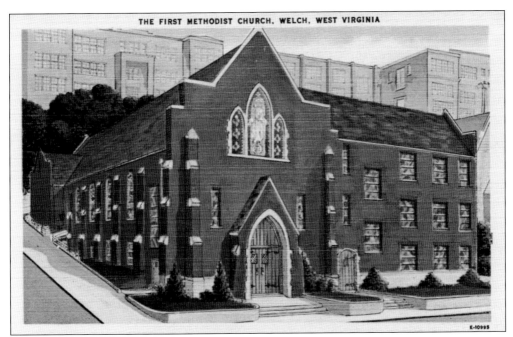

THE FIRST METHODIST CHURCH, WELCH, WEST VIRGINIA

This is the First Methodist Church in Welch, located on Virginia Avenue and facing the city hall. The brick church in this postcard image was the second Methodist church built. The original church, a wooden structure, was up the street to the right. The Methodist Church was founded in 1891 and was built on land from the Welch Land and Improvement Company.

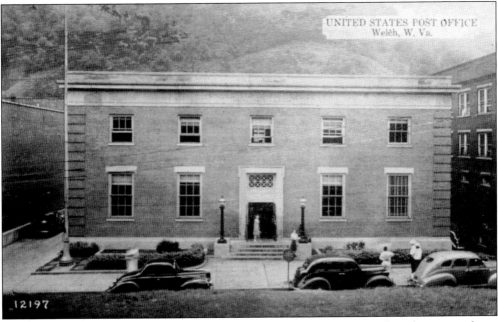

UNITED STATES POST OFFICE
Welch, W. Va.

This 1940s image of the US Post Office in Welch, was relatively new when this postcard was mailed. The post office faced the McDowell County Courthouse on Wyoming Street, and to the left is the Appalachian Power Company building. The building is used today as the McDowell Courthouse annex. Part of the property here was originally a playground.

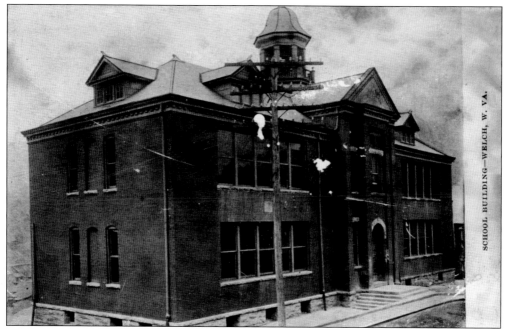

SCHOOL BUILDING—WELCH, W. VA.

Shown here is the first permanent school building for Welch High School facing Court Street and was erected beside the McDowell County Courthouse. The building became the World War I Memorial Building after 1918 to honor veterans from the surrounding area. A new high school was built on Maple Avenue above the First Methodist Church later in the 1920s.

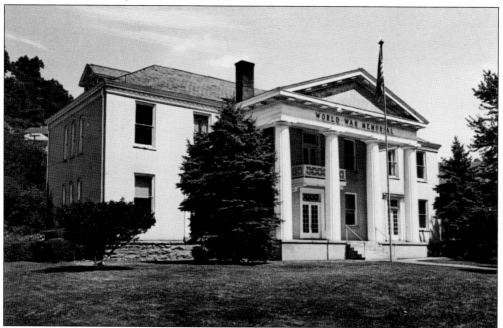

This postcard image of the World War I Memorial Building in Welch was the first ever built in the United States to remember our veterans from World War I. This building was originally the Welch High School, which faced the opposite direction. During reconstruction, the front was moved to the other side. The structure was destroyed by fire in the 1970s.

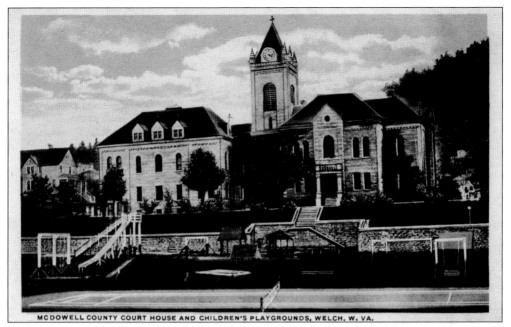

MC DOWELL COUNTY COURT HOUSE AND CHILDREN'S PLAYGROUNDS, WELCH, W. VA.

The McDowell County Courthouse, located in the city of Welch, was built around 1893 from native stone. In the early years, a children's playground was built across the street in front with merry-go-rounds, slides, and swings. The courthouse was the sight of several gun battles and a hanging.

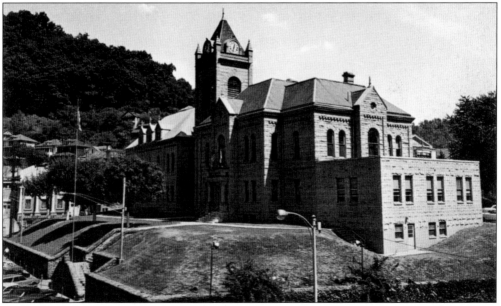

This 1960s view of the McDowell County Courthouse shows a new addition built on the right-hand side. The McDowell County Court was created by the legislature in 1893, and T.L. Henritze was appointed by Gov. William A. McCorkle as the first presiding jurist. Samuel V. Fulkerson of Abingdon, Virginia, was the first circuit judge. The first court session was held on August 23, 1858, at the home of George W. Payne at Perryville, which is now English, West Virginia, the first county seat. The courthouse was later moved to Welch.

17

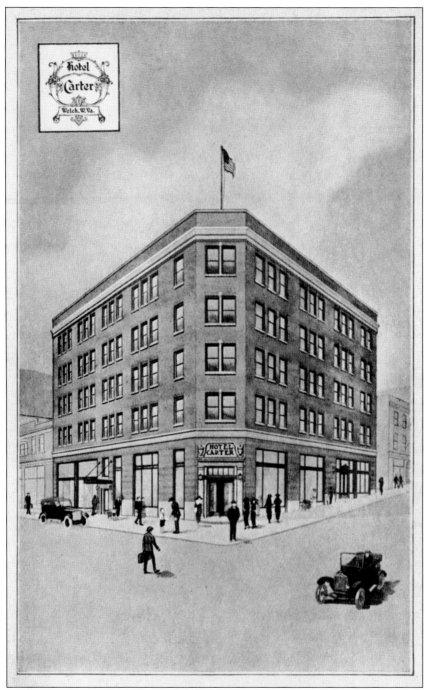

The famous Hotel Carter, located at the corner of McDowell Street and Bank Street in Welch, West Virginia. The Carter Hotel opened April 1, 1924, and was the finest hotel in Welch with small shops and the Central Cafe. Its lobby was constructed using the finest marble and brass railings. When business people arrived on the Norfolk & Western passenger trains, they were transported by taxi to the front door, where an attendant would take their bags and treat them with the upmost courtesy.

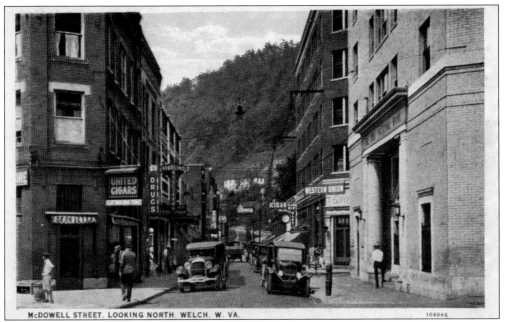

McDOWELL STREET, LOOKING NORTH, WELCH, W. VA.

This is an early view of McDowell Street in downtown Welch. This was a busy town at the time this postcard was produced. Retail outlets in Welch included 12 automobile dealers, 9 gas stations, 3 bakeries, 2 beverage bottlers, 5 beauty parlors, 18 clothing stores, 8 department stores, 3 movie theaters, 6 musical stores, 2 opticians, and 25 restaurants, and the population in 1930 was 5,376. The best of goods were available here as much as any big cities like New York or Chicago.

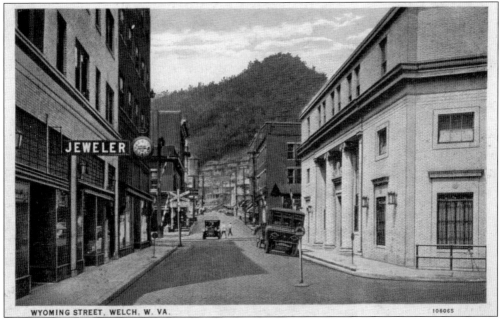

WYOMING STREET, WELCH, W. VA.

This 1920s view of Wyoming Street in Welch shows the Merchant and Miners Bank, which began business December 22, 1919. Also in the background is the Norfolk & Western Railway track through town. The railroad station is out of view on the right side, and the streets were paved with brick in the beginning.

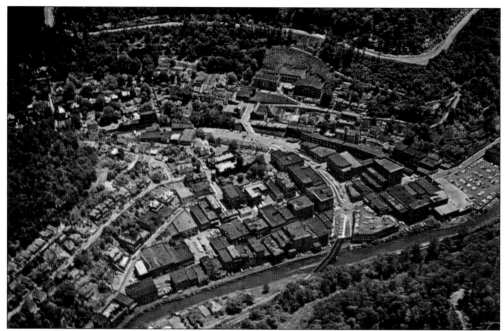

This aerial view of Welch, taken in the 1960s, shows how many structures were built and developed between the two mountains along the banks of Elkhorn Creek and the Tug River. Welch has the distinction of having the first parking building in the United States, constructed in September 1941.

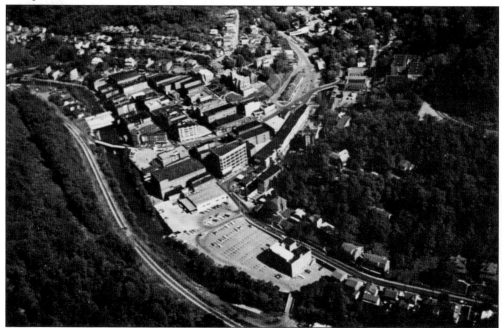

Another aerial view of Welch shows the bus terminal and Riverside Drive. The railroad tracks in the left corner are the Tug branch of the Norfolk & Western Railroad. The Tug branch ran through Havaco, Wilcoe, Gary, Thorpe, Pageton, Anawalt, and Leckie from Welch. As can be seen, most homes were built on the side of the mountains.

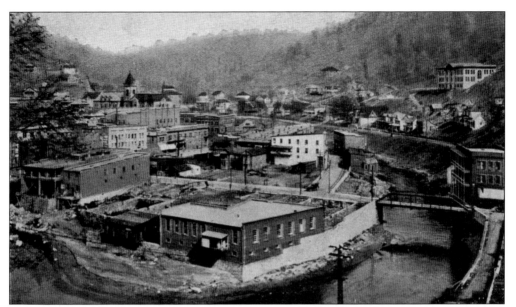

This 1920s bird's-eye view of Welch looking east shows where the Elkhorn Creek meets the Tug River. McDowell Street is the main street and Elkhorn Street is along the Elkhorn Creek. The area in the center shows lots that have not yet been developed. Several structures, including the Dor building, would be built on the lot at a later date on the corner of McDowell Street and Elkhorn Street.

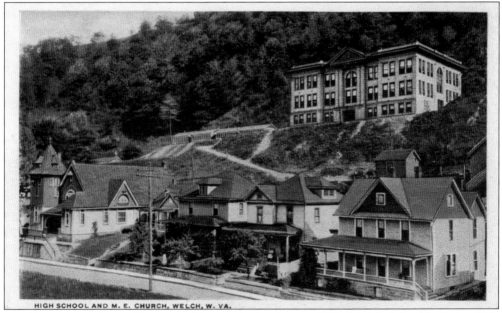

HIGH SCHOOL AND M. E. CHURCH, WELCH, W. VA.

Dated January 6, 1938, this postcard image shows the new Welch High School built in 1912, the Methodist church, and four historic homes. The wooden Methodist church, situated on the upper corner of the street, would be replaced later with a brick structure. In time, two school buildings would be erected to the left of the school and a gym with classrooms on the second floor. The author attended school here from 1963 to 1967. The Catholic church was built in this location, replacing two of the homes. Virginia Avenue is in front of the church and homes.

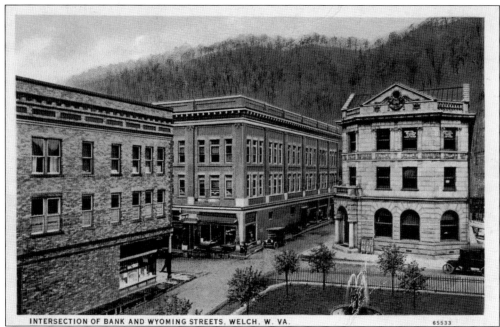

INTERSECTION OF BANK AND WYOMING STREETS, WELCH, W. VA. 65533

This is the intersection of Bank and Wyoming Streets in the 1920s. McDowell County National Bank is on the right side, and the Welch Drug Company is on the left corner. The park is still being used today with benches and brick walkways. All the streets during the early years were paved with brick.

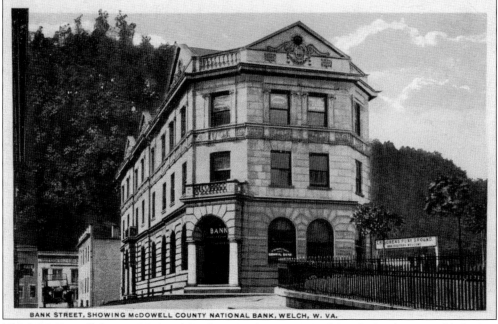

BANK STREET, SHOWING McDOWELL COUNTY NATIONAL BANK, WELCH, W. VA.

This is McDowell County National Bank on Bank Street in Welch. The bank was established on May 15, 1900, under a state charter with capital of $25,000. Some of the first board of directors members were Isaac T. Mann, Jenkin Jones, J.B. Perry, and I.J. Rhodes. The McDowell County National Bank is still operating today.

22

This earlier view of McDowell County National Bank was published by the Welch Drug Company in Welch. The streets around the building are still dirt. The lot on which the three-story bank building is located was purchased from the Bank of Bramwell for $700. The bank originally opened for business on January 2, 1900, in another location in Welch.

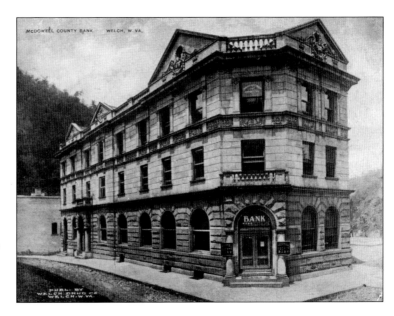

The Dor building and business section of Welch are depicted in this postcard image. The Dor building was an auto storage facility on the upper floors, and the Consolidated Bus Terminal lines were on the main floor. The entrance was located on the corner of McDowell Street and Elkhorn Street.

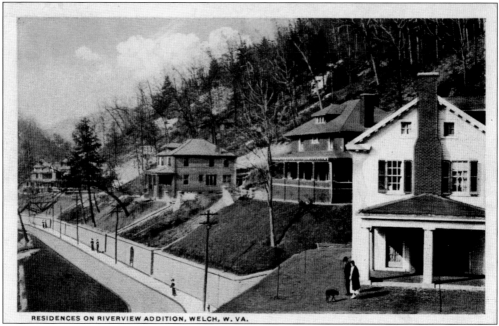

RESIDENCES ON RIVERVIEW ADDITION, WELCH, W. VA.

These are residences on Riverview Addition, which was later changed to Riverside Drive, in Welch. The white two-story home belonged to John Blakely, who was a long-term mayor of Welch. Blakely built the famed Pocahontas Theater for $100,000, with a seating capacity of 1,000. The theater burned down in the late 1970s.

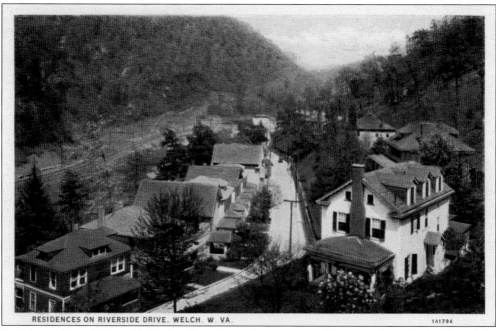

RESIDENCES ON RIVERSIDE DRIVE, WELCH, W. VA. 1A1794

This later view of Riverside Drive show three times as many homes built on both sides of the street. This scene looks toward Welch and the Norfolk & Western Railways Tug branchline is on the left. Notice the catenary electric system over the tracks. These were for LC1 and LC2 electric engines that were used until 1950.

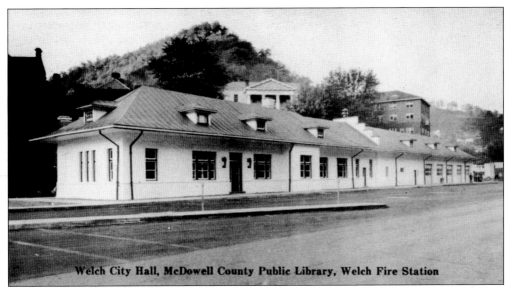

Welch City Hall, McDowell County Public Library, Welch Fire Station

After the Norfolk & Western Railroad station location was moved, the building was given to the city of Welch for a city hall, fire department, and the McDowell County Public Library. The building was destroyed by fire in the 1970s.

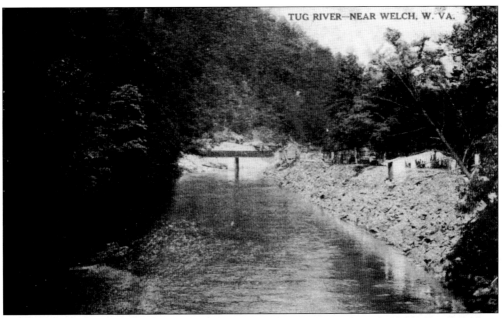

TUG RIVER—NEAR WELCH, W. VA.

This image is of the Tug River at Welch. The river is named from an incident that took place in the winter of 1756. Maj. Andrew Lewis was appointed to command an expedition ordered by Gov. Robert Dinwiddie to march against the Shawnees on the Ohio River and proceed to direct his men against the Shawnee villages, located near the Great Kanawha River. Major Lewis led his men within a few miles of the Ohio River, when a messenger carrying orders for a return of the expedition. The whole party suffered during this march because they ran out of provisions. They were reduced to cutting their buffalo skins into tugs and eating them, hence the name of the Tug River.

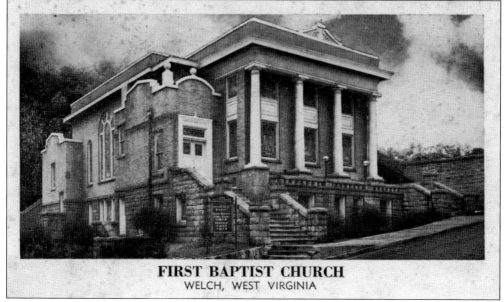

FIRST BAPTIST CHURCH
WELCH, WEST VIRGINIA

The First Baptist Church in Welch is located on the corner of Wyoming Street and Court Street. The Welch Daily News office is located across from the church. The church bought property adjacent to the church to build a hall for events, wedding receptions, and dinners. The church is still being used today for services. (Courtesy of Sammy Frost.)

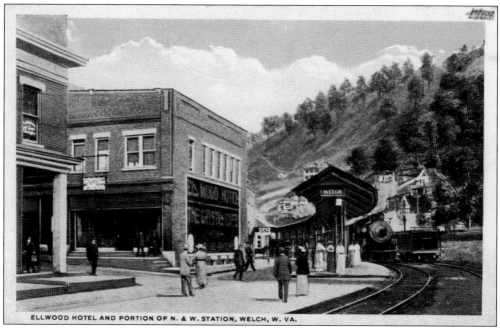

ELLWOOD HOTEL AND PORTION OF N. & W. STATION, WELCH, W. VA.

An early view shows the Elwood Hotel and the Crystal Cafe situated on Wyoming Street. The end of the Welch railroad passenger station platform shows passengers waiting to board the Norfolk & Western passenger trains. The opposite corner is where the old Kroger grocery store was located. This postcard image dates back to the 1920s. (Courtesy of Lacy Wright Jr.)

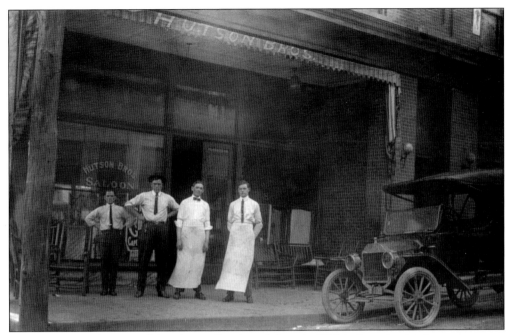

This is a postcard image of the Hutson Brothers Saloon in Welch. Intoxicating beverages were available at such amusement and entertainment establishments. There were several saloons in McDowell County, which were very popular on Saturday nights in the coalfield towns.

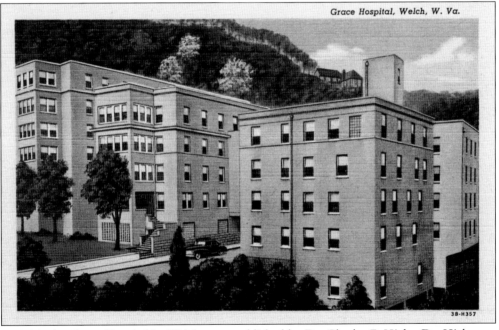

Grace Hospital, Welch, W. Va.

In 1923, the Grace Hospital in Welch was established by Dr. Charles F. Hicks. Dr. Hicks was superintendent of Welch No. 1 Hospital before he started Grace Hospital. Virginia Avenue ran under the hospital, where an enclosed walkway joined both sides of the structures. The hospital was demolished in later years. The English tutor home above the hospital was that of Dr. Charles Chapman.

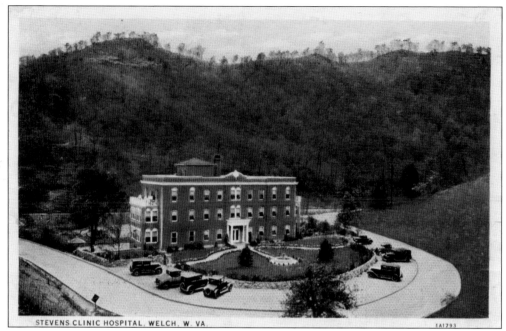

STEVENS CLINIC HOSPITAL, WELCH, W. VA.

This early image shows the Stevens Clinic Hospital in Welch. Old US Route 52 ran around the hospital. The hospital opened in 1930 and was connected to the Bluefield Sanitarium. Dr. Harry G. Camper of Welch, Dr. W.B. Stevens of Kimball, and Wade St. Clair and R.O. Rogers of Bluefield opened the hospital.

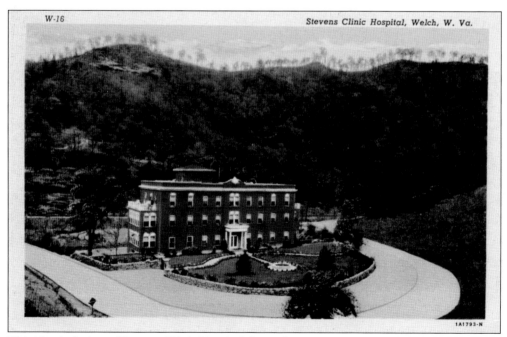

W-16 Stevens Clinic Hospital, Welch, W. Va.

This identical view of Stevens Clinic Hospital shows the structure as it was originally built. The hospital started with 100 beds but expanded to 140 beds later. Another structure was built in 1948 as a home for nurses. When US Route 52 was changed, it ran behind the hospital.

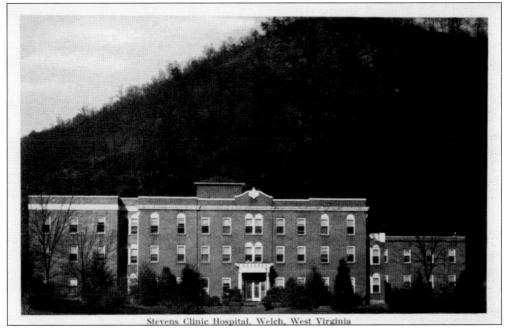

A later image of Stevens Clinic Hospital shows the improvements to the structure due to the demand of medical services in McDowell County. The 1930 census shows a population of 90,479. The hospital closed in 1987. In 2006, the building was remodeled for the new Stevens Correctional Facility.

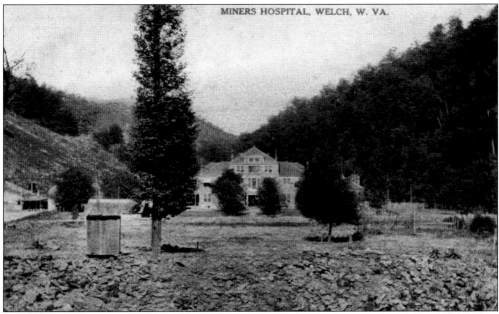

This 1908 postcard image is of the Miners Hospital, built in 1900 in Welch. Later, Stewart Street would be constructed on the right side and eventually become part of State Route 16. Many coal miners and their families came here for any and all medical services. Note that a lot of the trees were cut on the hill to the left side. The virgin timber in the area was cut from 1890 to 1920 to be used in construction.

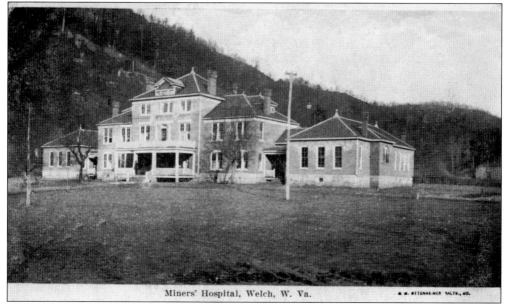

Miners' Hospital, Welch, W. Va.

This is another image of the Miners Hospital in Welch, dated November 1907. By the time of this postcard image was taken, the hospital had added two wings to help take care of the increasing number of miners and their families. The population had exploded because of needed workers in the mining industry in the Pocahontas Coalfield.

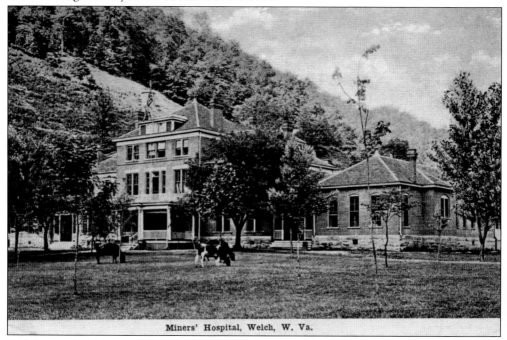

Miners' Hospital, Welch, W. Va.

This interesting image of the Miners Hospital in Welch has cows grazing on the front lawn. One of the most influential doctors that was associated with the Miners Hospital was Dr. Henry D. Hatfield. He came from the Thackerfield to the Pocahontas Coalfield in 1899, and then to Eckman, West Virginia, to setup a practice for several coal companies. He was a surgeon at the Miners Hospital until 1903.

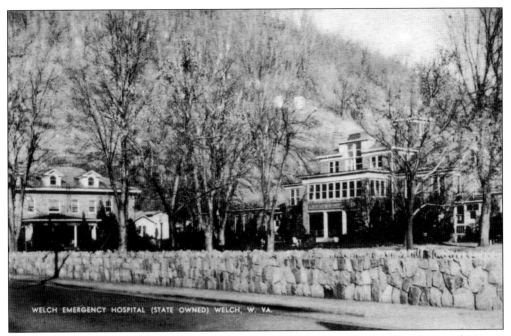

WELCH EMERGENCY HOSPITAL (STATE OWNED) WELCH, W. VA.

The Miners Hospital's name was changed to Welch Emergency Hospital and Nurses' Home. Several wings have been added out of necessity to treat the growing population. The nurses' home is the brick building to the left. The construction of homes would be built later on the hill behind the nurses' home.

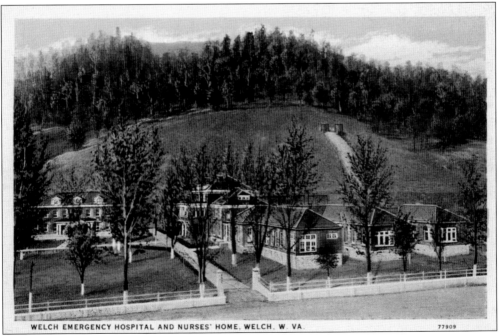

WELCH EMERGENCY HOSPITAL AND NURSES' HOME, WELCH, W. VA. 77909

This postcard is a later view of Welch Emergency Hospital, which was a state-owned institution. The street in the foreground is Stewart Street, which was part of State Route 16. The addition of the rock wall enhanced the facility.

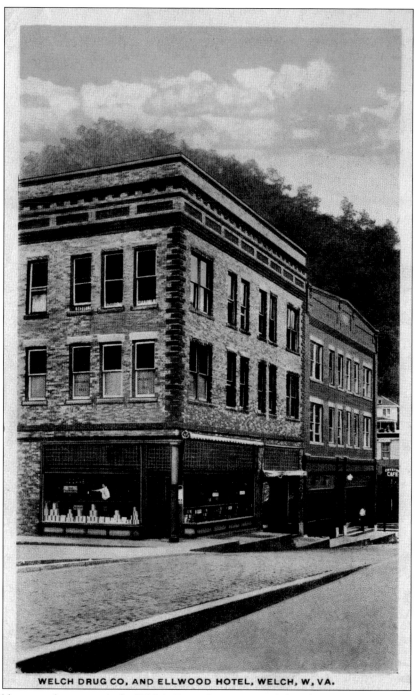

WELCH DRUG CO, AND ELLWOOD HOTEL, WELCH, W, VA.

Pictured here on the corner is the Welch Drug Company and the Elwood Hotel in Welch. The Elwood Hotel operated the Crystal Cafe for its customers, offering some of the best cooked food in town. These two buildings are located on Wyoming Street next to the McDowell County Courthouse. After the fire on January 12, 1911, most of the buildings were constructed of brick and stone. Most early structures built of wood perished in the fire. This postcard image is from around the 1920s. The McDowell County National Bank would be across the street.

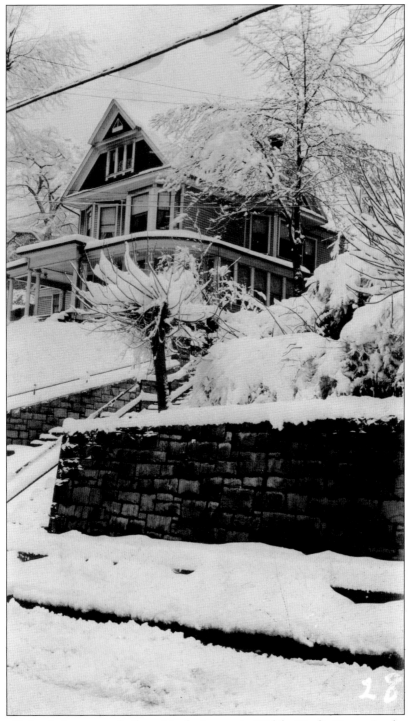

This beautiful early home was built on Maple Avenue in Welch. Maple Avenue is where several business owners resided. As with all towns in the coalfields, cut stone was the standard for foundations and walls. Most of the stonework was done by Italian stonemasons throughout McDowell County. Snowfalls in the 1930s and 1940s were heavy at times.

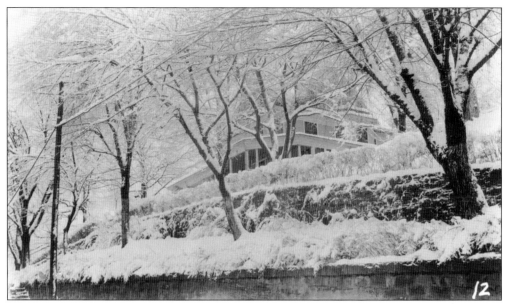

This snow scene was captured on Maple Avenue in Welch. Large homes were built on the street of the Victorian variety, as well as elaborate brick styles. Most had beautiful cut stone walls that held back the banks to make the foundations stable. This postcard image would make a great Christmas card.

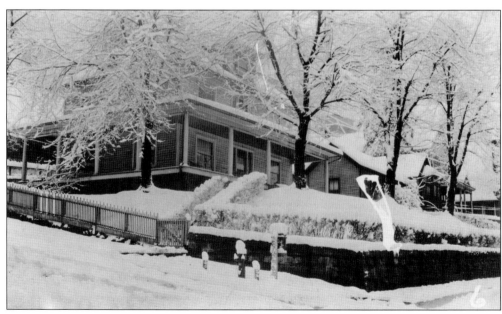

This beautiful home is at the corner of Virginia Avenue and Bridge Street in Welch. The design of the homes had a wraparound porch and wooden picket fences. Both of these homes were later demolished to build the new First Methodist Church. The old Methodist church can be seen in the extreme right of the postcard.

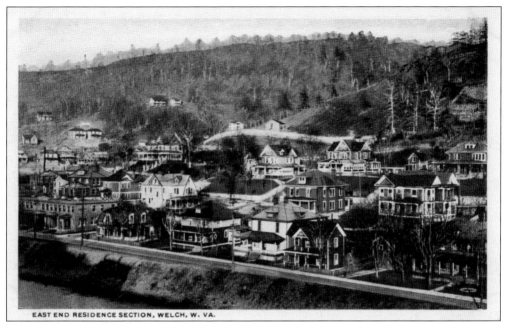

EAST END RESIDENCE SECTION, WELCH, W. VA.

Shown here is a 1930s view of Virginia Avenue leading into Welch. The street behind the homes is Maple Avenue. The fifth house to the left in the front row is where the McDowell County 911 Center is now. An early apartment building is on the left corner of the scene. (Courtesy of Lacy Wright Jr.)

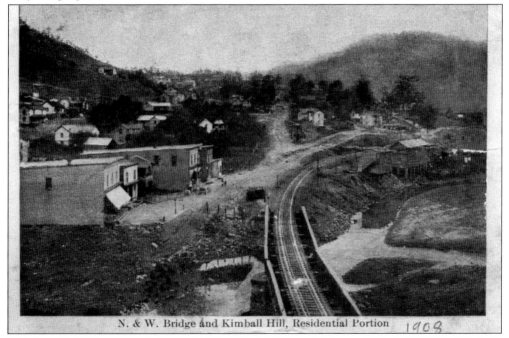

N. & W. Bridge and Kimball Hill, Residential Portion 1908

This June 5, 1908, postcard shows old Norfolk & Western bridge and Kimball Hill in Kimball, West Virginia. From the 1890s to around 1904, the railroad mainline came through town. On the hill is the residential portion of Kimball, and the road up the hill was the main road before the new US Route 52 was built.

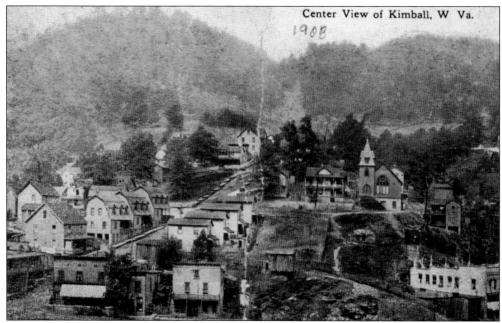

Center View of Kimball, W Va.

1908

This 1908 center view of Kimball shows typical houses, apartment buildings, and churches that were built on the steep side of the mountains. As with most of the early structures, they were built of wood. The postcard was published by the Grogan Brothers, who had various stores in Kimball.

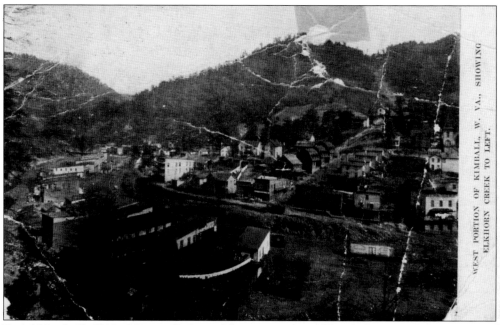

WEST PORTION OF KIMBALL, W. VA., SHOWING ELKHORN CREEK TO LEFT.

Dated March 31, 1908, this overall view of the west portion of Kimball shows Kimball Hill and the town built on the banks of the Elkhorn Creek. Note that clothes are hung on lines to dry between the buildings. The Norfolk & Western mainline ran through town and had multiple tracks for storage and for businesses. The town was named for Frederick J. Kimball, the second president of the Norfolk & Western Railway.

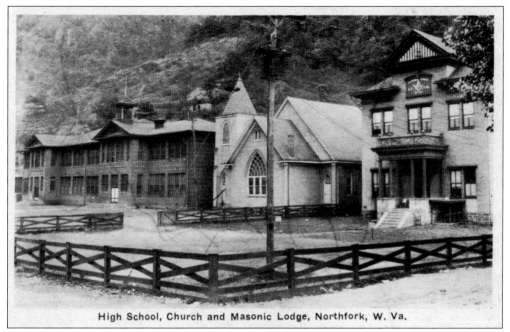

High School, Church and Masonic Lodge, Northfork, W. Va.

Pictured here are the high school, the church and the Algoma AF & AM in Northfork, West Virginia. This structure faced the Norfolk & Western Railway mainline. The population was increasing due to the rapid expansion of the mining of coal. New construction was constant in the coalfields during the golden years. The school shown here was replaced by the early one-story wooden structure.

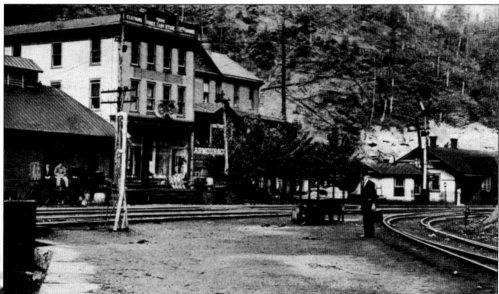

This historical postcard depicts the hotel, the Armour Meat Packing Company, and the Norfolk & Western Railway passenger station in Northfork. The mail crane to the left is where mail was prepared and put into a mailbag to be hung for the railway post office (RPO) car on the passenger train to pick up as it passed. The railroad track to the left is the Northfork branch line, where there were 12 major coal companies operating within this six-mile stretch.

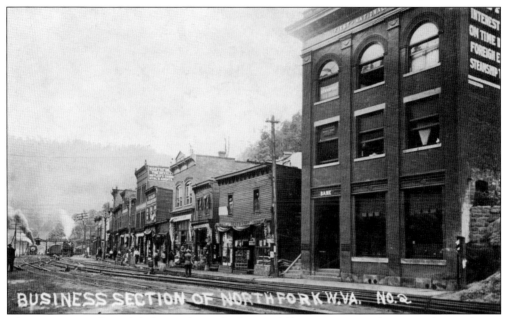

The main street of Northfork was alongside the Norfolk & Western Railway mainline as shown in this real-photo postcard dated April 1913. The steam engines in the background are under a coaling facility that loads coal into the steam engines' tenders for fuel. In the foreground is the First National Bank Building, and in the center is the Northfork Drug Store. The town is busy with people shopping or banking on this day.

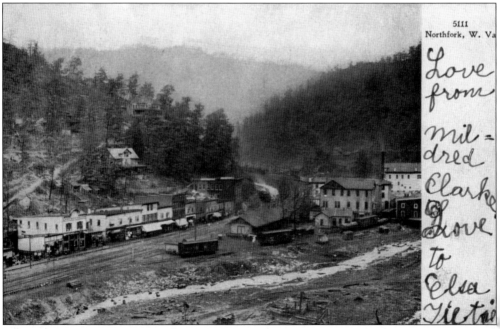

This is an opposite view of Northfork dated August 29, 1907, showing the Norfolk & Western passenger station, stores, Armour Meat Packing Company, and homes on the hillside. The stream winding through the town is the Elkhorn Creek. Northfork has an altitude of 1,706 feet above sea level, and the principal industry is coal.

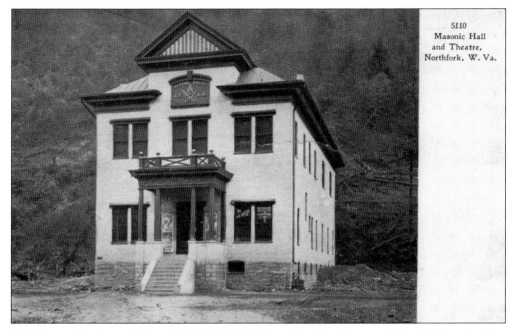

The Algoma Lodge and Masonic Hall No. 94 is pictured with a theater and Dr. A. Salyers's office in Northfork. The building was new at the time of this photograph; however, the postcard is dated April 20, 1908. In later years, the construction of US Route 52 and several homes would take place behind the lodge.

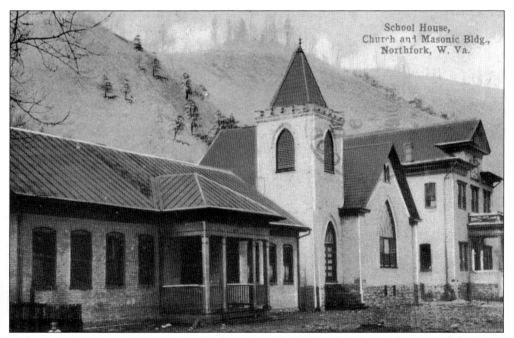

In this October 5, 1910, postcard are the first school building, church, and the Masonic building in Northfork. The one-story school was later replaced with a two-story larger brick building. The mountains were timbered for wood to be used in construction of homes and early businesses.

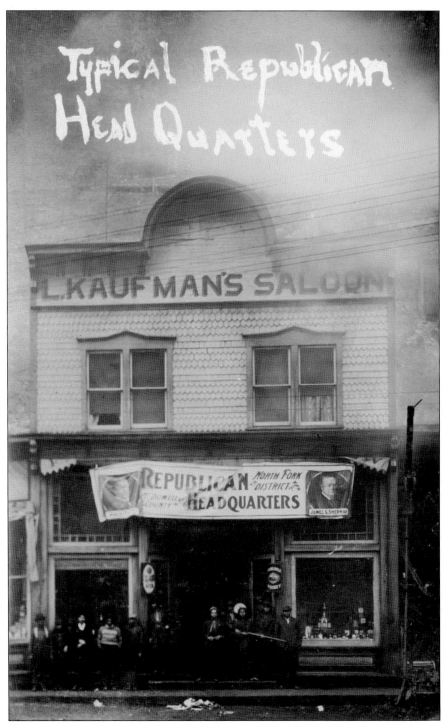

This undated postcard shows L. Kaufman's Saloon, which was the Republican headquarters for the Northfork District in McDowell County, located at the end of the town of Northfork. James S. Sherman pictured on the banner is running for this district. Several patrons are on the sidewalk with cue sticks, and beer and whiskey signs are displayed in the windows.

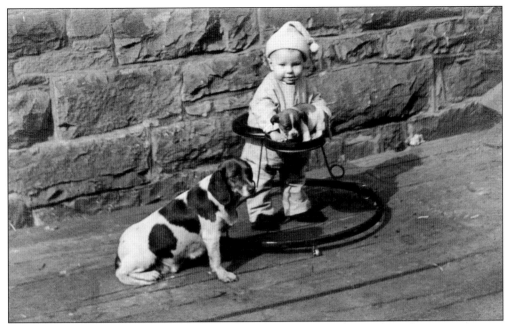

This photograph of a baby in a metal stroller, joined by a female dog and puppy, was taken in Maybeury, West Virginia. The cut stone wall is typical of walls built throughout McDowell County. Some were foundations of coal company stores. Coal company stores offered the top-of-the-line clothing, as evident with the baby's jumpsuit and toboggan. This image was captured in the afternoon sun while the photographer enjoyed a stroll through the community.

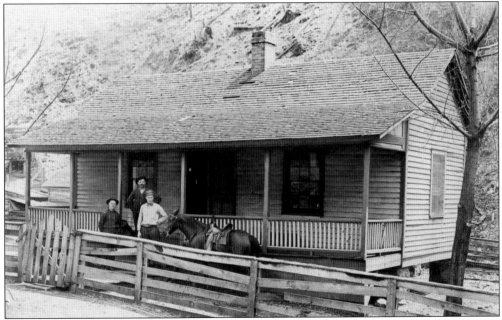

Another early real-photo postcard shows a coal company house with several people in the front yard in Maybeury. Because of the location of the railroad tracks, this image was possibly taken in Barlow Hollow, which leads to Mill Creek Coal and Coke Company's mining operation. This miner's home seems to be in good repair, as most coal companies kept up their houses.

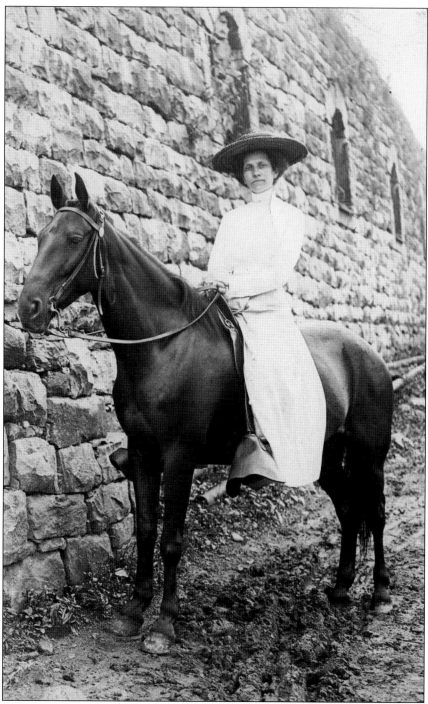

Produced in June 1911, this real-photo postcard scene shows a well-dressed lady on horseback out for an evening ride through the coal-mining community of Maybeury. In the background is a row of coke ovens, where coke was made by burning coal to burn off the impurities. Coke was shipped to steel mills and used in the production of steel, because it would burn hotter than coal.

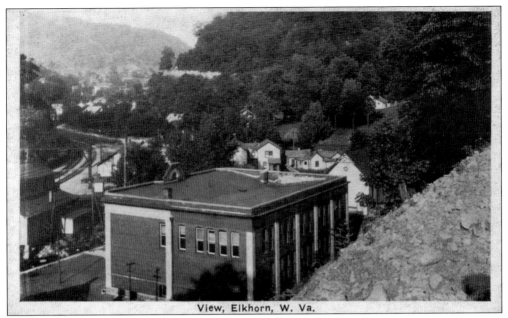

View, Elkhorn, W. Va.

This general view of Elkhorn, West Virginia, was published by the Bluefield Postcard Company of Salem, Virginia. Pictured are the Elkhorn School and the Norfolk & Western passenger station, along with several homes. The Crozer Coal and Coke Company and the Houston Coal and Coke Company had operations here. In the 1940s, the new US Route 52 would be built around the mountain side above the school.

A Typical Mountain and Highway Scene in West Virginia

This postcard view of Route 16 to Coalwood is a typical mountain highway scene in West Virginia. Coalwood is the home of the memoir Rocket Boys and is the community behind the movie October Sky. Carter Coal Company had coal operations in Coalwood, Six, and Caretta. Later in the 1940s, the coal company name was changed to the Olga Coal Company.

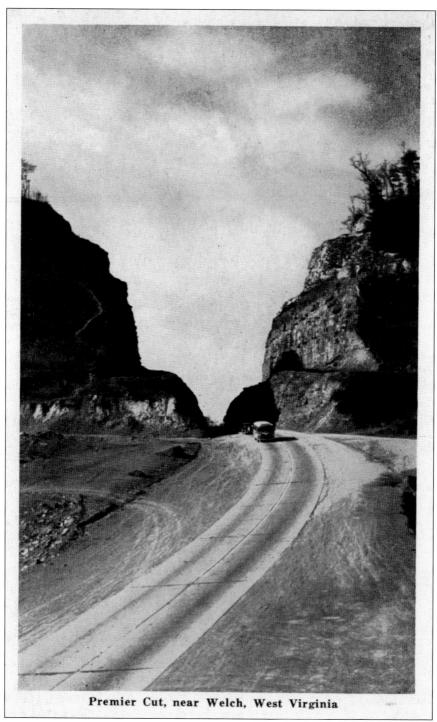

Premier Cut, near Welch, West Virginia

US Route 52, shown here near Welch, West Virginia, had been in use for several years when this postcard photograph was taken. The road passes through Premier Cut, known at one time as the deepest cut in the United States. The bus in the postcard image is from either Price Bus Lines or Trailways Bus Company, which ran through McDowell County. (Courtesy of Geneva Steele.)

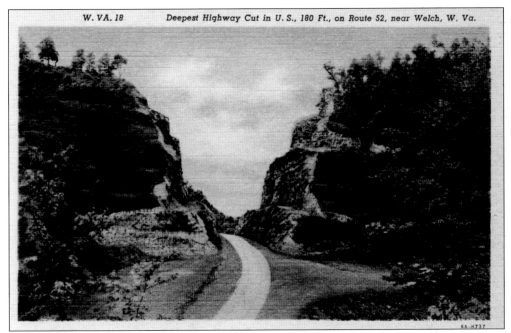

Another postcard image shows Premier Cut on US Route 52, looking toward the coal-mining community of Premier, West Virginia. US Route 52 ran between Bluefield and Williamson, West Virginia, passing through towns of Northfork, Keystone, Kimball, Welch, Iaeger, and Gilbert. This road was completed after World War II. Premier cut was 180 feet high when construction was completed.

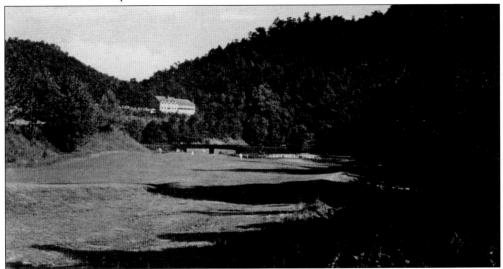

The famous Gary Country Club near Skygusty, West Virginia, with its nine-hole golf course, was provided for by the United States Coal and Coke Company for its employees. The company employed thousands of miners and had 10 operations in Gary Hollow. The name changed later to United States Steel Corporation (commonly known as U.S. Steel). In the 1950s, the company built the world's largest coal-mining cleaning plant in Gary. The clubhouse was later demolished in the late 1990s. The nine-hole golf course is still being used by patrons around McDowell County. (Courtesy of Geneva Steele.)

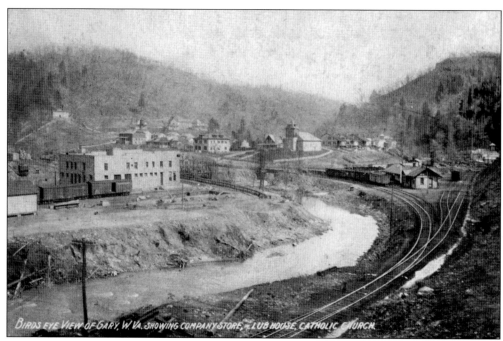

A bird's-eye view of Gary shows the brick and cut stone coal company store, the Gary clubhouse, and the Catholic church. The Tug branchline of the Norfolk & Western Railway is shown in the foreground. This postcard image is dated June 30, 1909.

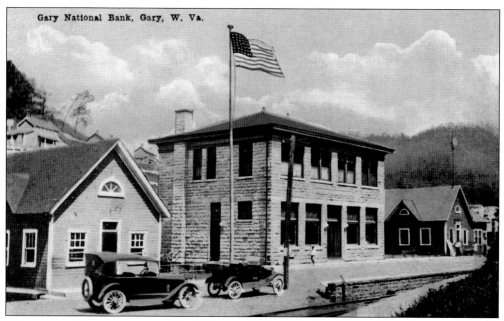

This postcard image was captured in the heart of Gary. The beautiful, well-built stone structure, erected in 1913, is the new Gary National Bank. On the hillside in the background are some of the miners duplexes built by the United States Coal and Coke Company. This structure houses the Gary Coal Diggers Museum today.

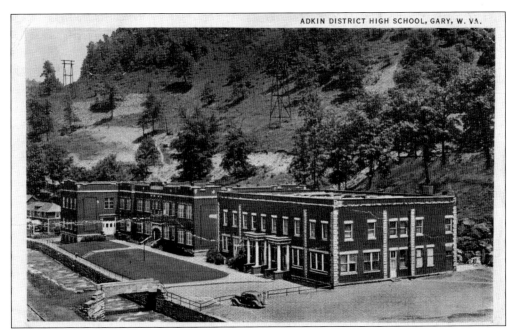

McDowell County was on the leading edge of school construction, as shown by this example of the Adkin District High School in Gary. This school was in operation until the late 1970s, when several schools were consolidated due to population loss. This postcard is dated May 9, 1938, and was mailed from Wilcoe, West Virginia.

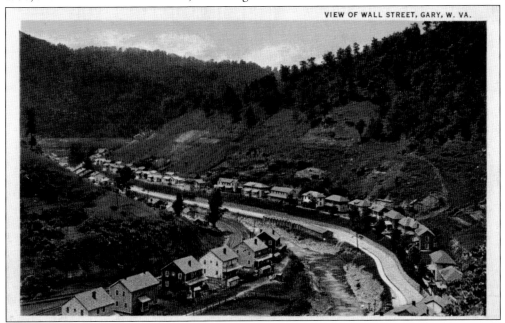

This postcard, dated August 4, 1938, shows the view of Wall Street in Gary. U.S. Steel mining operation is on the other side of the hill, just out of view. Many of these homes are still there today, located along the Tug River. Wall Street was named for its cut stone wall, built just below the homes on the road. The city of Gary is named after Judge Elbert Gary of Illinois Steel Company.

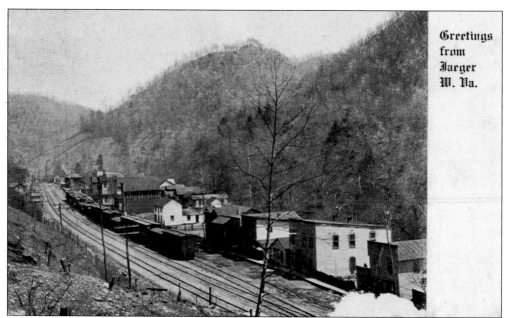

This postcard view of the main street in Iaeger, West Virginia, is dated April 20, 1907. The town is named for Col. William G. W. Iaeger. The Norfolk & Western Railway's Auville railroad yard is located here off of the mainline and the Dry Fork branch. Iaeger was incorporated in September 1903 and had 3 banks, post office, 2 hotels, a theater, and 28 other businesses in the early 1920s.

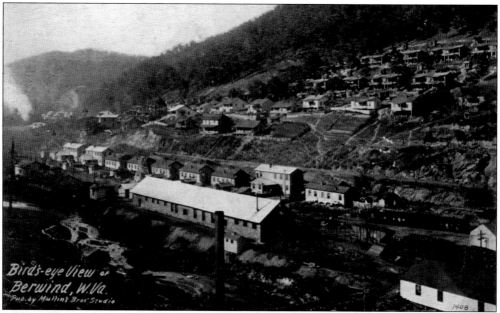

This coal-mining community is Berwind, West Virginia, where the New River and Pocahontas Coal Company had a mining complex with a briquet plant. The community of Berwind was built by the Berwind-White Coal Mining Company of Pennsylvania in the late 1890s. The briquet plant made briquets from a process where slack coal was mixed with a bonding agent and ran through a moulding machine. Briquets were a cleaner way for commercial and home heating.

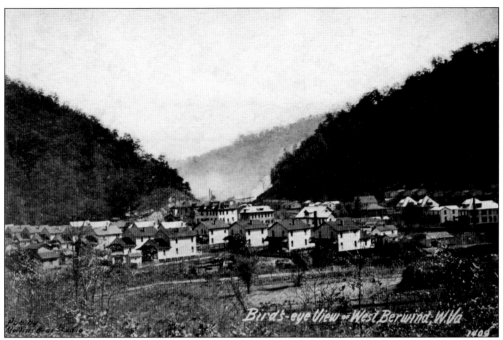

This is an overall view of West Berwind, West Virginia, showing most of the homes, the coal company store, and the bank. The Norfolk & Western Railway was on the left along the mountain side. This line ran on to Bluefield, West Virginia, through Cedar Bluff, Virginia. The railroad reached Berwind in April 1906.

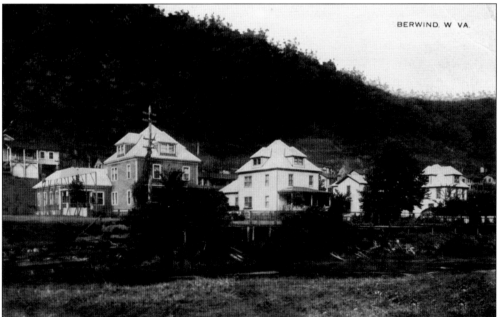

This is another early postcard view of several two-story homes in Berwind around 1910. As with most homes, they were built of wood and featured cut stone foundations. Homes of this size were usually meant for store managers, doctors, mine bosses, and coal company superintendents. Most coal companies kept a crew of carpenters on the payroll for constant painting and up keep.

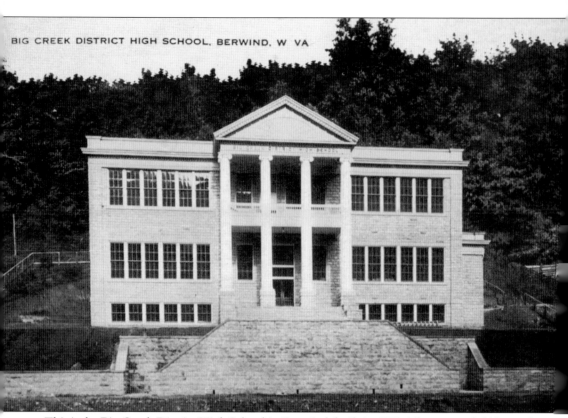

This is the Big Creek District High School in Berwind, built in 1912. There were 2,392 people living in Berwind, according to the 1910 census. This school operated until about 1932, when it was consolidated with a new Big Creek High School in War, West Virginia.

This original postcard, dated February 23, 1882, was mailed in Perryville, West Virginia, and sent to Baltimore, Maryland. Perryville was the first county seat for McDowell County before Wilcoe and, eventually, Welch. The signature on the back of the postcard is of John F. Johnson, who was the McDowell County clerk from 1879 to 1891.

Born in Story County, Iowa in 1862, the Reverend Billy Sunday was an evangelist who traveled the United States spreading the word of God with tent revivals. Reverend Sunday was a major league baseball player for 8 years before becoming an evangelist. He would frequent the southern coalfields with his sermons. He died November 6, 1935, at the age of 72.

Two

COAL OPERATIONS

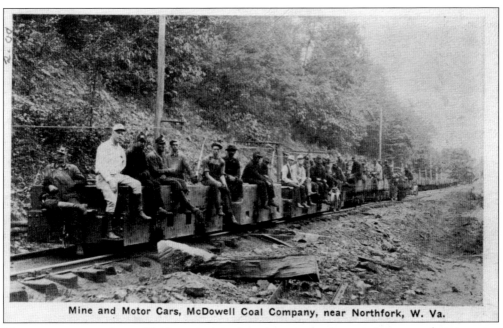

Mine and Motor Cars, McDowell Coal Company, near Northfork, W. Va.

Many men came to the coalfields to work in the mines, as seen here, sitting on an electric motor and mine cars of the McDowell Coal and Coke Company in the community of McDowell, West Virginia. This mine was a few miles from the town of Northfork and was incorporated in 1891. The McDowell Coal and Coke Company mined the Pocahontas No. 3 coal seam. William Beury and John Cooper were the owners of this company.

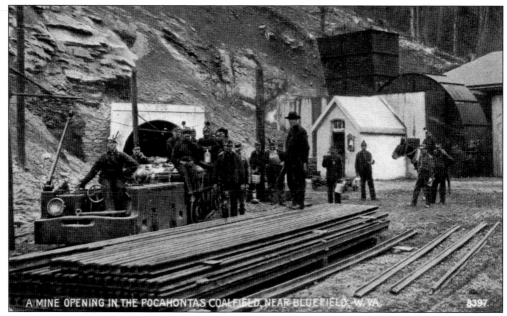

This is a typical early postcard image of a mine opening in the Pocahontas Coalfield near Bluefield, West Virginia. The concrete face has a builder's date of 1906. The building in the background is a fan house that was connected to the mine to keep fresh air flowing for the men working inside. The miners have cloth hats with wick lamps that burn oil. Notice the aluminum dinner buckets they carry with them.

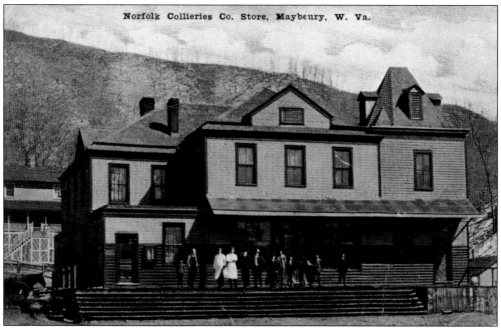

Coal company stores were the hub of the communities, as evident of this early postcard image of the Northfork Angle Colliery Company Store in Maybeury, West Virginia. These stores stocked first-rate goods for the coal miner and their families. This coal company was incorporated in 1888 and operated until around 1958.

54

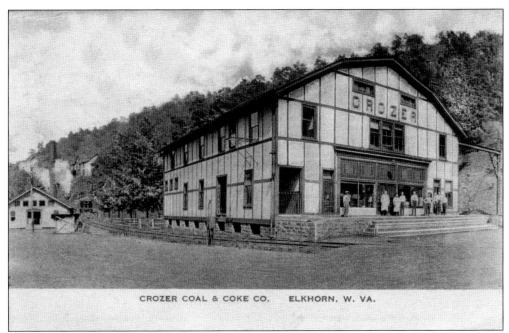

CROZER COAL & COKE CO. ELKHORN, W. VA.

Pictured in this postcard is the Crozer Coal and Coke Company store in Elkhorn, West Virginia. The largest structures in the communities usually were the stores. In this image is the powerhouse, which generated electricity for the operation, located just above the store. The postmark on this postcard is July 25, 1939, and was mailed at the Elkhorn Post Office. Crozer Coal and Coke Company was incorporated in 1887.

CROZER-POCAHONTAS COMPANY

BLUEFIELD, W. VA., ---- APR 19 1926 ---- 1925.

Advance notice of coal consigned today. Settlement to be made in accordance with our invoice.

CAR INITIAL	CAR NO.	WEIGHT	GRADE	ROUTE
N&W	79068	98600	EGG	N&W
Above car shipped to			T. J.	Andrews, Mgr., Hollins Station, Va

31711 7-1-25 3m

This Crozer-Pocahontas Company postcard is how the company communicated with customers for shipments of coal in the early years. They would inform them of the shipment of a railroad car of coal and the car number, along with weight and grade of coal. This card is dated April 19, 1926.

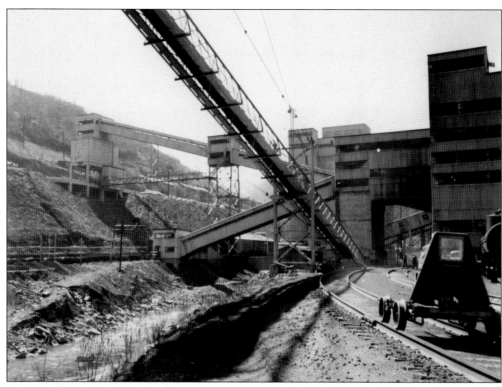

This image is of the U.S. Steel plant in Gary, West Virginia, which was built on both sides of the Tug River. The Norfolk & Western Tug branch line ran underneath the plant to the right. This preparation plant's construction was completed in 1948, and it operated until 1986.

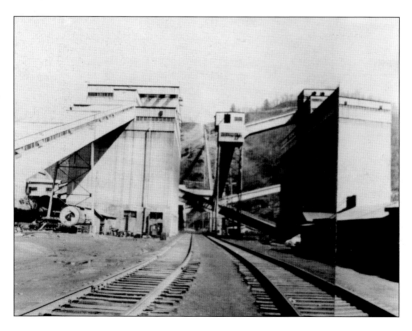

This opposite view of the U.S. Steel plant shows the conveyor systems for the processing and mixing of coal from various mining operations before shipment. The long conveyor going up the mountain is removing refuse (or waste) after processing. The large structures are the coal blending bins.

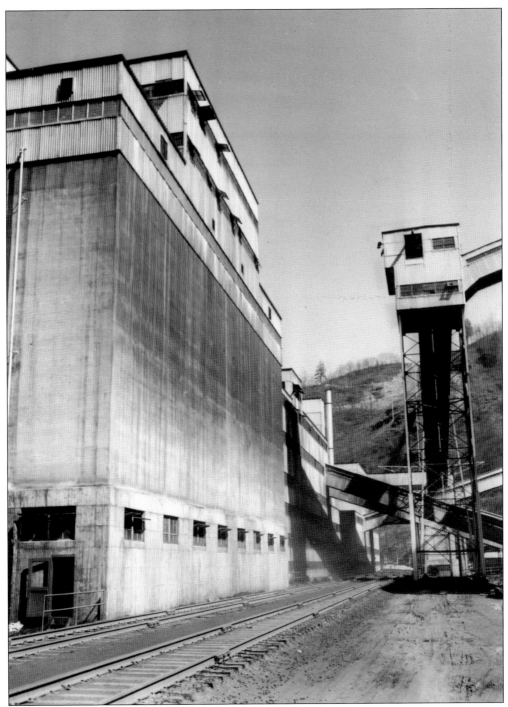

A closer look at the coal-blending bins at the U.S. Steel plant in Gary, West Virginia, reveals just how massive they were. Between the two structures, there were 112 bins. This plant was equipped to provide five sites of coal for preparation. Coal was brought from other U.S. Steel operations in Gary by railcar and dumped into the blending bins.

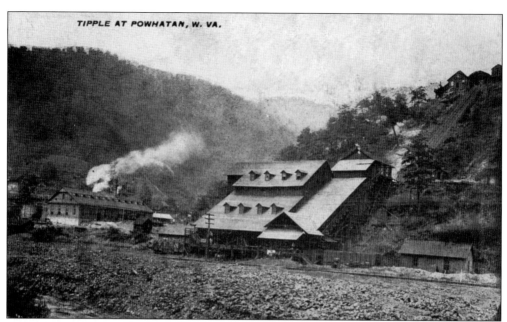

Located alongside the Norfolk & Western mainline is the Powhatan Coal and Coke Company in Powhatan, West Virginia. This coal company was in operation until 1937. This community is where the first Catholic Church was established in McDowell County. The Norfolk & Western passenger train pulled by J-class steam engine No. 604 wrecked here on Powhatan curve.

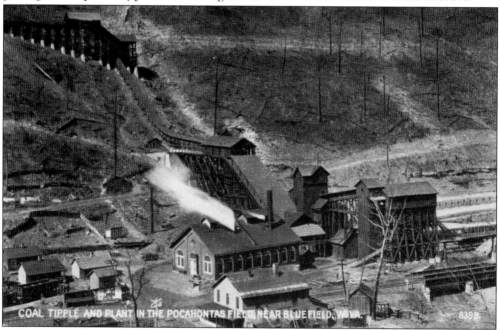

This March 20, 1912, postcard shows the Lynchburg Coal and Coke Company at Kyle, West Virginia. The image shows the coal tipple, powerhouse, support structures, and the double-track mainline of the Norfolk & Western Railway. Coal was mined above and brought down through conveyors to railcars. In the 1940s, US Route 52 was built on the hillside above the mining complex.

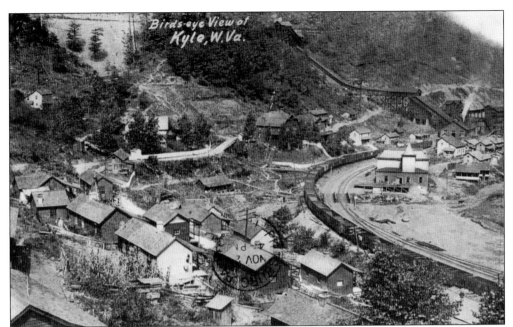

This bird's-eye view of Kyle, West Virginia, shows the community, mine, and the coal company store of the Lynchburg Coal and Coke Company. This operation began in 1890 after acquisition of the property for a coal lease from Crozer Land Company. The Lynchburg mine operated until 1940. The community of Kyle was named after C.M. Kyle from Virginia, an early coal operator in the area.

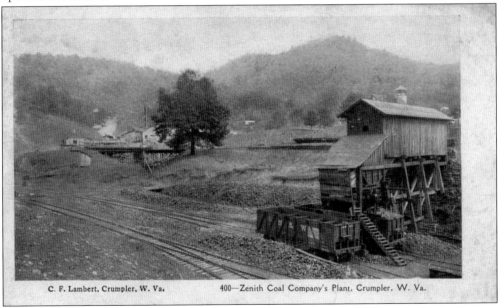

C. F. Lambert, Crumpler, W. Va. 400—Zenith Coal Company's Plant, Crumpler, W. Va.

The Zenith Coal Company of Crumpler, West Virginia, is seen in this postcard dated February 7, 1913. The operation was incorporated in March 1903. This image shows the original wooden structure as built. In the late 1920s, a new more modern metal tipple was built to handle five loadout railroad tracks for railroad cars. In 1915, the coal company name was changed to the United Pocahontas Coal Company.

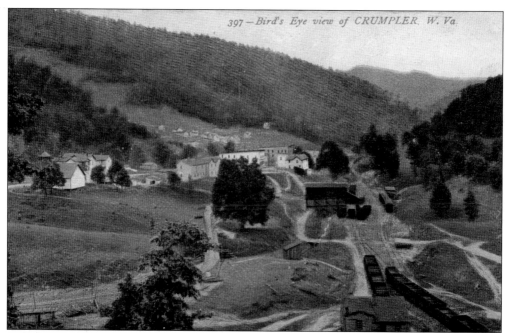

397 — *Bird's Eye view of CRUMPLER. W. Va.*

This view of Crumpler looks back down toward Ashland, West Virginia. The town of Northfork was six miles away from this community. Early in the development, there were seven stores, two theaters, a drugstore, railroad passenger station, and a jail. The postcard dated July 19, 1908, shows Zenith Coal and Coke Company from the opposite side.

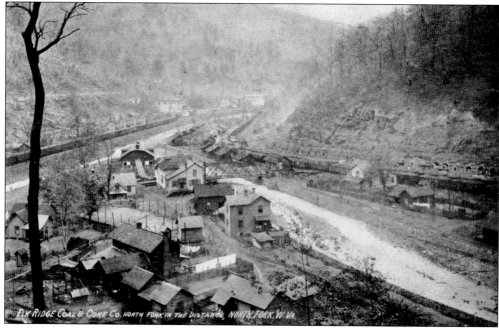

The community of Elkridge Coal and Coke Company was built along the Elkhorn Creek and next to the town of Northfork. The mine was on the Northfork branch of the Norfolk & Western Railway and was established in May 1892. The 1910 census listed 50 inhabitants at Elkridge. The coal company operated until 1924.

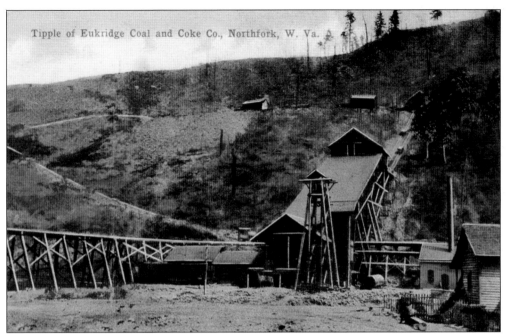

Tipple of Eukridge Coal and Coke Co., Northfork, W. Va.

This original early postcard is of the Elkridge Coal and Coke Company. The company mined the Pocahontas No. 3 seam of coal. The first railroad car of coal was shipped on February 8, 1893. The coal was mined above the operation and brought down by mine car on an incline.

PAIS POCAHONTAS COAL COMPANY

Issue to me and charge my account with
TEN DOLLARS

Issued to ... Roll No.

Issued by .. On19

$10.00 No. 1424 C

Coal companies had their own credit system by using scrip at the company stores. Pictured here is an original rare $10 paper book of scrip for the Pais Pocahontas Coal Company, which had a loadout along US Route 52 at Upland, West Virginia. The company mined older coal leases until 1962.

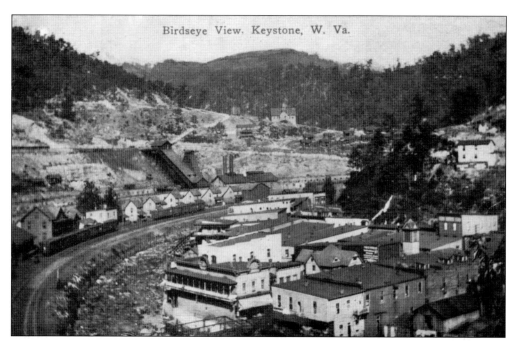

This original real-photo postcard of Keystone, West Virginia, is dated April 27, 1913. The postmark is from the RPO (railroad post office) car on train No. 16 of the Norfolk & Western passenger train. The coal company here, the Keystone Coal and Coke Company, was incorporated in July 1890.

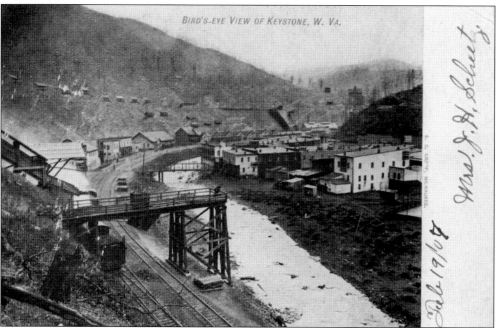

This closer postcard view of Keystone, West Virginia, dated February 19, 1907, shows the town and Keystone Coal and Coke Company mine. The facility in the forefront loads coal into the tenders of the railroad steam engines. Note the coal company houses on the hillside in the left background.

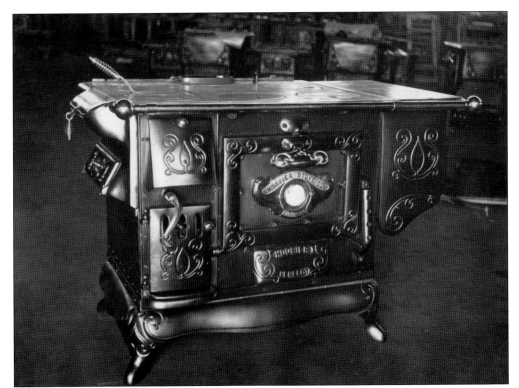

This cooking stove, made by the Hoosier Stove Company of Marion, Indiana, would have been sold through many coal company stores in the southern coalfields. These would also be a source of heat in coal company houses during a long cold winter for anyone baking pinto beans and buttermilk cornbread.

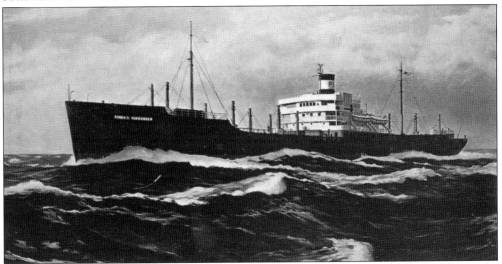

Some larger coal companies had their own steamships. Pictured here is the SS *Oakey L. Alexander*, owned by the Pocahontas Steamship Company. They also owned the SS *Pocahontas Fuel*. These vessels were the largest and fastest coastline ships in the world. Each is capable of delivering 12,000 net tons of "Original Pocahontas Coal." These ships served New England and the far corners of the world. Most ships were loaded at Lamberts Point in Norfolk, Virginia.

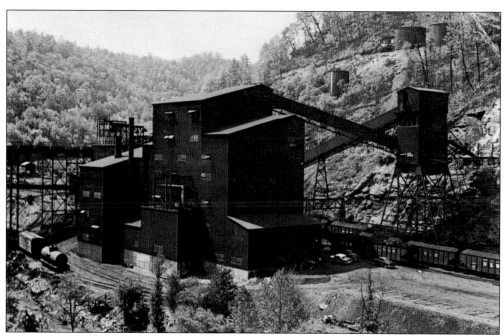

Shown here is a modern coal preparation plant made of structural steel and metal covering. This operation was served by the Norfolk & Western Railway. In the background is a bridge for loaded mine cars to dump coal into bins to sort out. The postcard is dated April 19, 1963.

Pocahontas Fuel Company owned several operations in McDowell County. This mine here is their Pocahontas Colliery in Pocahontas, Virginia, located across the mountain from McDowell County, which later became the Pocahontas Exhibition Mine. The main office for the Pocahontas Fuel Company was also located here. The exhibition mine is still a scenic tourist attraction today.

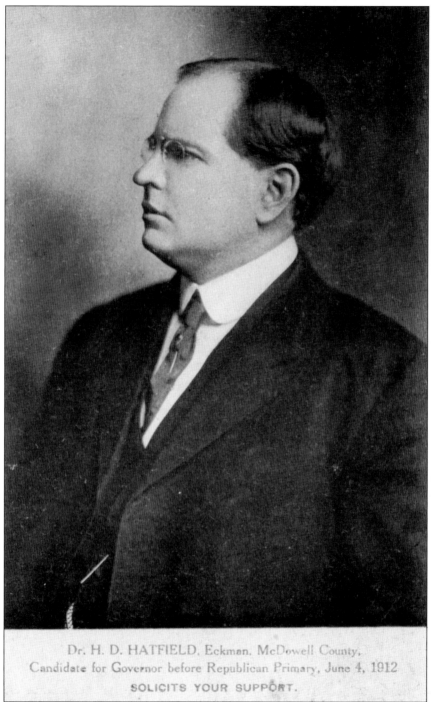

Dr. H. D. HATFIELD, Eckman. McDowell County,
Candidate for Governor before Republican Primary, June 4, 1912
SOLICITS YOUR SUPPORT.

Dr. Henry D. Hatfield had a doctor's office for the Pulaski Iron Company in Eckman, West Virginia, before 1912. Hatfield was elected governor of the state of West Virginia in 1912. This original postcard, dated May 15, 1912, was mailed to potential voters during the election campaign. Hatfield arrived from the Thacker Field in Logan County, West Virginia. He also was involved with the early coal mine wars at Cabin Creek and Paint Creek in West Virginia.

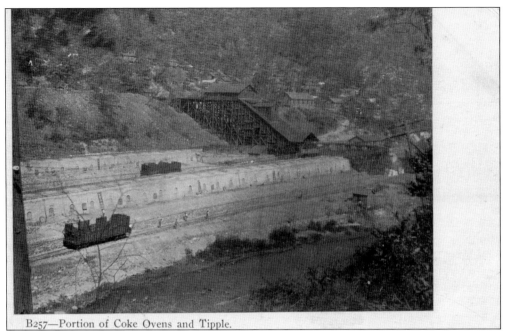

B257—Portion of Coke Ovens and Tipple.

This early postcard of the Empire Coal and Coke Company in Landgraff, West Virginia, is dated October 20, 1907. This coal company opened in 1887 and operated until 1938 before being sold. The original property was leased from Elkhorn Valley Coal Company. In the 1950s, Landgraff, located 1,573 feet above sea level, had 1,000 inhabitants.

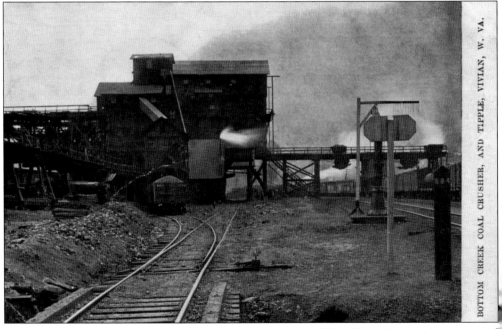

BOTTOM CREEK COAL CRUSHER, AND TIPPLE, VIVIAN, W. VA.

The Bottom Creek Coal and Coke Company in Vivian, West Virginia, was incorporated in October 1891. The coal company operated from 1892 to 1926. In 1927, the Pocahontas Corporation took over the coal lease. This mine was located about one mile south of Kimball, West Virginia. This postcard is dated October 19, 1909.

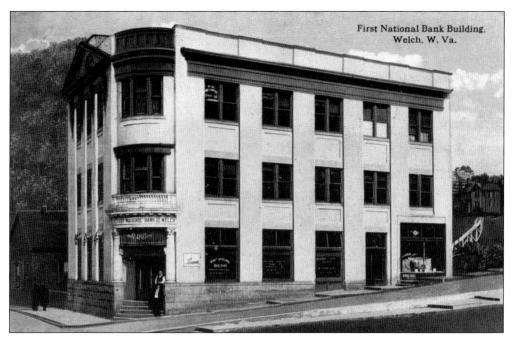

In this original postcard, dated November 20, 1923, is the First National Bank Building in Welch, West Virginia. This bank is on the corner of McDowell Street and Bank Street. This bank was organized in April 1, 1902. It was originally called the Citizens Bank, before the name changed in 1908. The bank building was torn down around 1924 for the construction of the famous Carter Hotel. The offices of the West Virginia Pocahontas Coal Company, the Lathrop Coal Company, and the Panther Coal Company were on the third floor. (Courtesy of Lacy Wright Jr.)

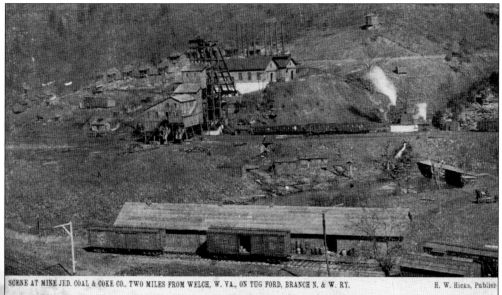

SCENE AT MINE JED. COAL & COKE CO., TWO MILES FROM WELCH, W. VA., ON TUG FORD, BRANCH N. & W. RY. H. W. Hicks, Publish

This early postcard scene is of the Jed Coal and Coke Company, located two miles from Welch on the Tug branch of the Norfolk & Western Railway. The tall structure with bullwheels is common with deep shaft mines and is usually the tallest part of the mining complex. The Jed Coal and Coke Company was incorporated in December 1903.

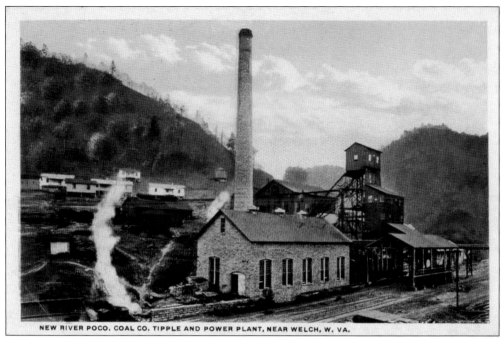

NEW RIVER POCO. COAL CO. TIPPLE AND POWER PLANT, NEAR WELCH, W. VA.

The Jed Coal and Coke Company suffered a mine explosion on March 26, 1912, that killed 83 men. In 1913, the New River and Pocahontas Consolidated Coal Company took over the operation. The community of Jed's name was changed to Havaco. The name of Jed came from Maj. Jedediah Hotchkiss, and the name of Havaco was derived from Havana, Cuba, where the coal company had an office.

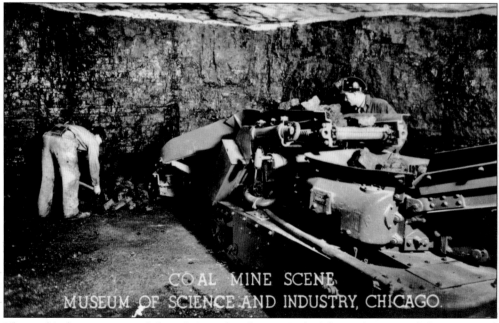

COAL MINE SCENE
MUSEUM OF SCIENCE AND INDUSTRY, CHICAGO.

The coal industry promoted the mining of coal extensively. This early postcard shows mining at the coal face with a mechanical loading machine. The Museum of Science and Industry in Chicago published many different postcards on the process of coal mining.

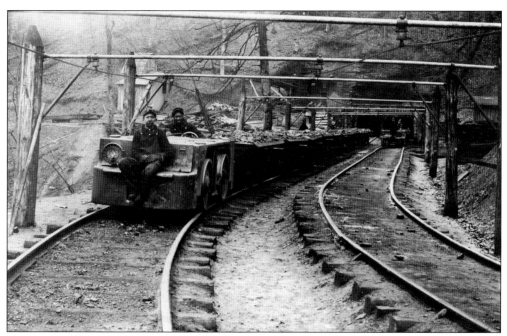

This early unidentified view shows a coal mine opening typical of most mines in the southern coalfields. The coal miners wear cloth hats and carbide lamps, which was common around 1913 to the late 1920s. Here, two electric mine motors and 10 loaded mine cars head toward the coal tipple for processing.

HOME OFFICE SUPPLY CO., WELCH. W. VA. 5M 1-28 A433

Central Pocahontas Coal Co.

All Coal billed according to N. & W. Ry. scale weight from which no deduction or allowance will be made.

Welch, W. Va. _____ 9 - 3 - 192 9

We consign to your account the following cars of coal:

ORDER	INITIAL	NUMBER	GRADE	ROUTE
O.381-X	6 7 0	37855	Radio 4" B.	N K P
				Meyers
				Siding

CENTRAL POCAHONTAS COAL CO. By _____

The Central Pocahontas Coal Company in Welch sent postcards to customers of the impending shipments of coal. Usually, the railroad route and car number were always provided for their records. The upper right notation says that all coal billed according to Norfolk & Western Railway scale weight of the loaded railroad cars will be made. This card is dated September 4, 1929.

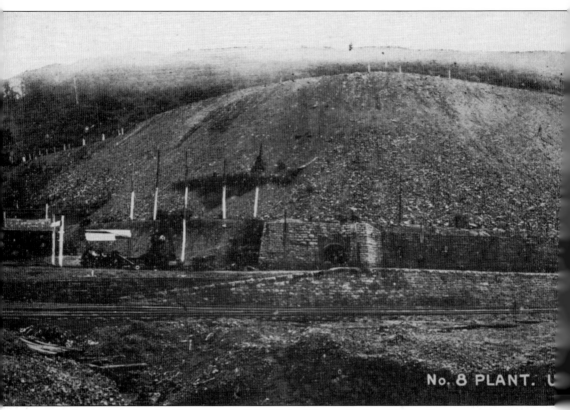

No. 8 PLANT. U

The image here is a double postcard of the United States Coal and Coke Company No. 8 plant, which started its operation in 1905. The card reads Gary, West Virginia, but the image actually shows Elbert, West Virginia, located about two miles from Gary. No. 8 was built generally for

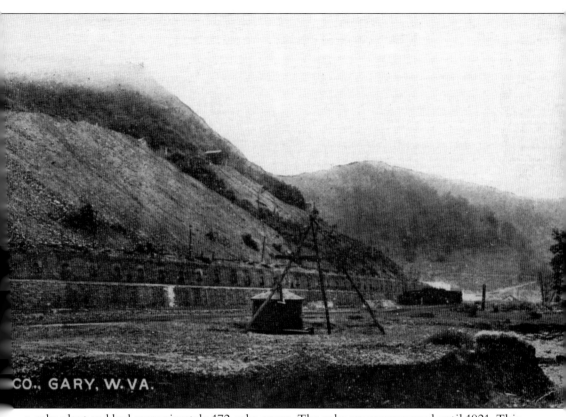

CO., GARY, W. VA.

a coke plant and had approximately 172 coke ovens. The coke ovens were used until 1921. This community of Elbert sprang up around the operation and was named for Judge Elbert Gary. At one time, Gary was the head of the company. The Elbert operation mined coal until 1938.

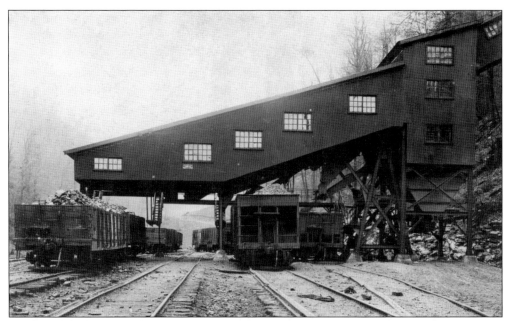

Another unidentified coal-mining operation located on the Norfolk & Western Railway. This tin-sided and metal beam–constructed coal tipple has four loadouts. The coal here is mined above and transferred down by chute. Some of the railroad cars are of an early design and were built of wood, as well as a metal frame with outside bracing.

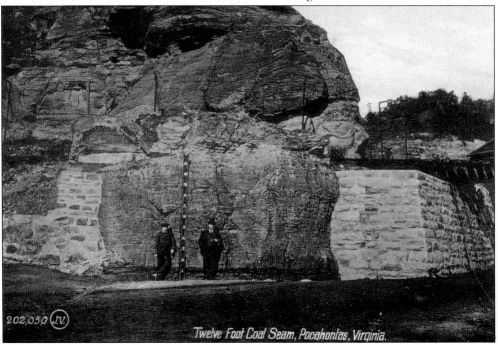

Twelve Foot Coal Seam, Pocahontas, Virginia.

Shown here is the 12-foot-high coal seam in Pocahontas, Virginia. This is the seam that started the influx of the coal-mining industry in Mercer County and across the hill in McDowell County. The outcrop coal seam was on the property of Jordan Nelson, a blacksmith in Pocahontas, Virginia. This postcard is dated January 18, 1908.

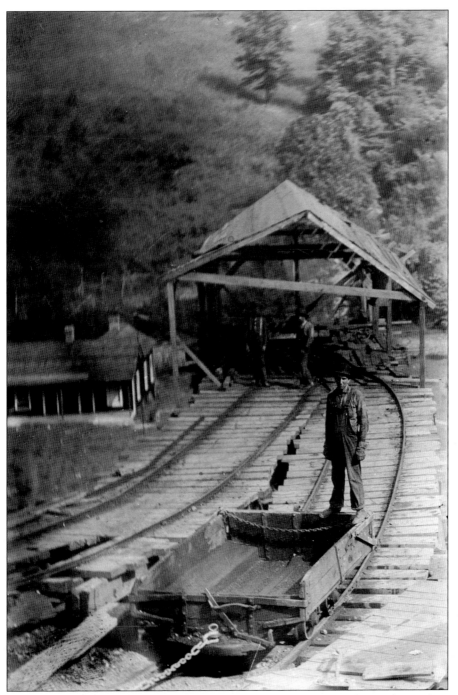

This real-photo postcard of a coal operation shows a mining method of an incline, where coal is mined above on the mountain side and lowered down in a mine car by chain. Coal-mining operations in the southern coalfields had no easy task due to the mountainous terrain. The mining companies had to carve out its existence and build the entire infrastructure to support the coal miners and their families. In the beginning, coal camps were primitive, but as years passed, they were built into modern coal communities.

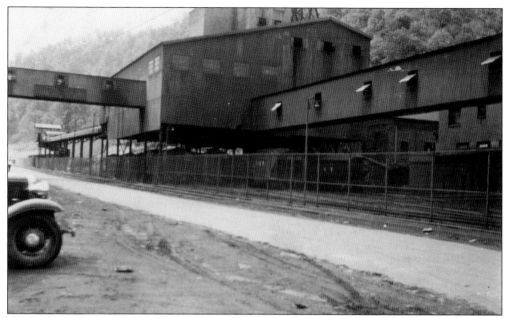

Pictured is the Olga Coal Company in Coalwood, West Virginia. The Olga Coal Company had two other operations located at Six and Caretta in West Virginia. According to the 1940 census, the population of Coalwood was 3,145. The population in the 1920 census was 1,850, which included the communities of Six and Caretta.

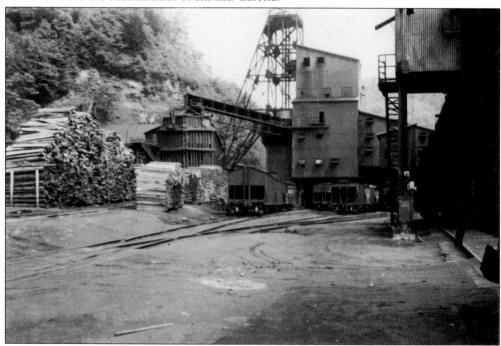

This opposite view of the Olga Coal Company No. 1 mine shows the hoist house and timber yard. This mine was originally owned by George L. Carter and was known in 1902 as the Carter Coal Company. Other interest, also were at Six and Caretta. The Consolidated Coal Company controlled the operation from 1922 to 1933.

Form 9 H H

SALES DEPARTMENT

POCAHONTAS FUEL COMPANY
INCORPORATED

MINERS, SHIPPERS AND EXPORTERS OF

ORIGINAL POCAHONTAS COAL

131 STATE STREET, BOSTON, MASS.

We forwarded on Oct. 31/18 the following
Cars of Coal

Car Initial	Car Number
MC	2515
	2771
UNITED STATES FUEL ADMINISTRATION	
LICENSE NUMBER X3752	

Weights and Invoice to follow.

Respectfully,

POCAHONTAS FUEL COMPANY INCORPORATED

By _John J Harwell_

This postcard, dated October 31, 1918, was used to send customers information about shipments of coal by the railroad. The railroad cars in reference here are for the Maine Central and were numbered 2515 and 2771. This note was sent during World War I, as evident of the stamping that reads "United States Fuel Administration, License Number X3752." Pocahontas Fuel Company located here had a sales department in Boston, Massachusetts. The celebrated Pocahontas coal mined in McDowell County was sold and shipped the world over. At one time, the world beckoned the door of McDowell County because of its smokeless coal, the modern mining practices, and the use of current technology.

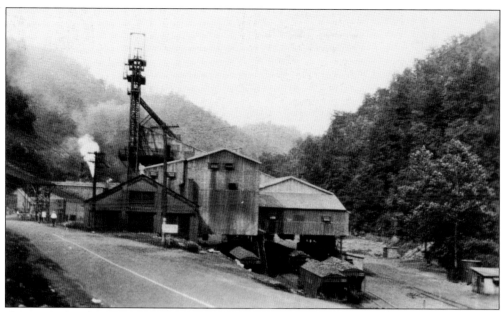

Carter Coal Company, pictured in this postcard from 1934, is the coal tipple at Caretta, West Virginia. The location is on state Route 16 from Welch to War. The Norfolk & Western Railway served this coal-mining operation with a siding off of the Dry Fork branch ,and the railroad satisfaction mine number was 4256.

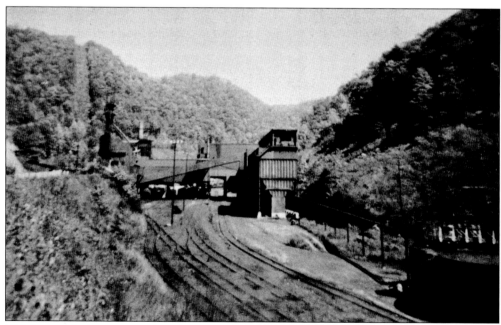

This later real-photo postcard is of the coal treatment plant of the Olga Coal Company, formerly the Carter Coal Company. In this view, the coal tipple had expanded due to the demand for coal. There are six loadout tracks for railroad cars.

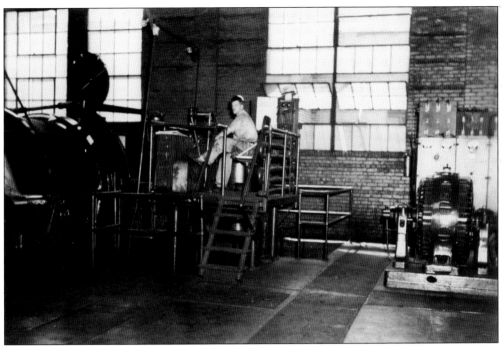

This is the hoisting machine in the engine room at the Olga Coal Company. It was used to lower and lift the cage in the shaft for coal miners and supplies. Most people look at coal mining as a dirty job, but the interior of the very well-kept facility is excellent for working conditions.

This advertising postcard, from Fall River, Massachusetts, promotes the type of coal and its prices. What is significant about this card is the name of William C. Atwater, who was the president of the Elkhorn Coal and Coke Company in Maybeury, West Virginia, and president of the Mill Creek Coal and Coke Company in Coopers, West Virginia, in the early 1900s. His company's office was in Fall River, Massachusetts.

OLGA COAL COMPANY
WAGE ASSIGNMENT FOR METAL SCRIP

Check
Number................................Employee..Amount $............

Mine..............................Date...

This will acknowledge the receipt by me at my request from OLGA COAL COMPANY of metal scrip in the amount above specified, which will be accepted by said Company in payment for merchandise sold at any of its stores if and when presented by me for such purpose.

In consideration of the foregoing, I hereby assign to said Olga Coal Company any wages, in excess of the minimum wages and overtime compensation as such terms are defined in the Federal Fair Labor Standards Act, due or which may become due to me from said Company up to the full amount of metal scrip received by me and I hereby authorize said Company to deduct, in one or more payments, as it may elect, from such wages the amount of metal scrip received by me, until the same shall have been paid in full.

In the event that Olga Coal Company is for any reason unable to or fails to collect in full from such wages the amount of metal scrip received by me, I hereby agree to pay to Olga Coal Company, upon demand, the amount it is unable to or fails to so collect.

Signed..

Witness.. By..

This is an original copy of form WAC-369-Olga for wage assignment for metal scrip used by the Olga Coal Company. This shows the miner's check number, name, amount, mine number, and date of the request for scrip. The scrip would be used at the company store for goods and then the amount would be deducted from his regular paycheck. This was an early form of a credit system used by the companies.

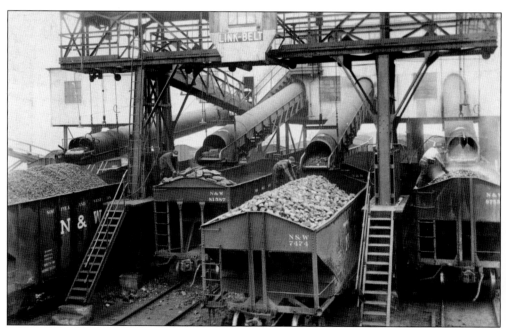

The loadout booms here load several grades of coal are of the Pond Creek Pocahontas Coal Company in Bartley, West Virginia. This is the company's No. 4 operation, which was incorporated in 1923 located on the east side of the Dry Fork River; the tipple was on the west side.

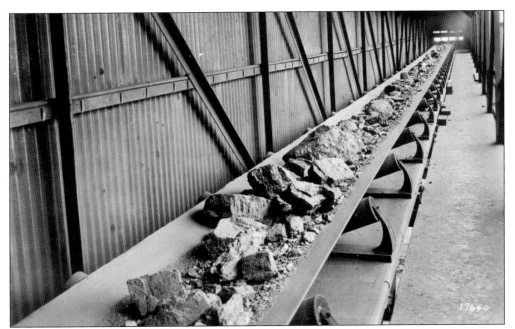

This conveyor is in the Pond Creek No. 4 mine at Bartley, West Virginia. The raw coal is brought down through the screens and washed for separation into different sizes. Looking at the coal, one can see lump, egg, pea, and slack varieties. Most coal operations used these methods.

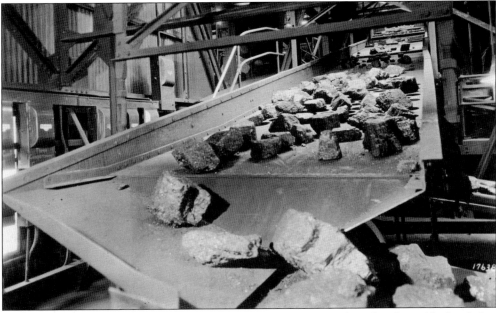

As coal continued down the chute, like this lump coal, it was ready to be cleaned before being loaded into railroad cars. Every ton of coal was processed this way. This postcard image is at the Pond Creek No. 4 mine in Bartley, West Virginia. In 1955, this company was merged into the Island Creek Coal Company.

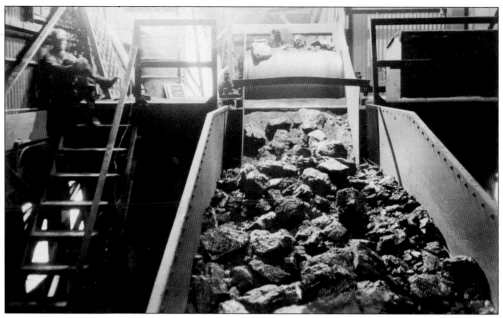

This is a continuation of how coal is processed inside a coal tipple. The coal moving here is being loaded into two-bay and three-bay railroad coal hoppers. An unidentified coal miner watches over the process. The coal mined at the Pond Creek mines was known as "4 Point Pocahontas Coal" for marketing purposes.

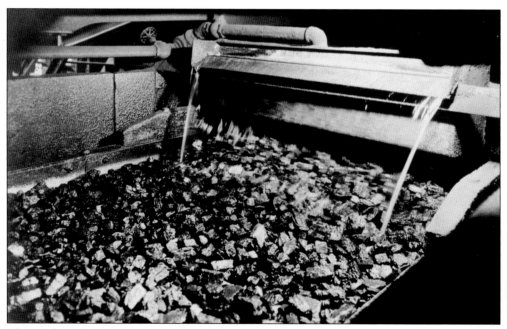

This coal washer prepares coal for market. As the coal passes through it is washed and later dried for delivery. Pond Creek's 4 Point Pocahontas Coal meant that the coal was clean, free burning, clinkerless, and had a firm structure. This is an original postcard from the Pond Creek Pocahontas Coal Company between Raysal and Bartley in West Virginia.

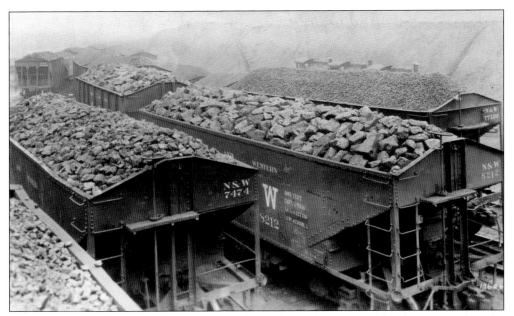

This view of coal already loaded at Pond Creek Pocahontas mine at Bartley shows several grades of coal. There are several different Norfolk & Western early two-bay and three-bay hopper cars on the loadout tracks. In the background are three small steam engines used to move railcars at the coal tipple.

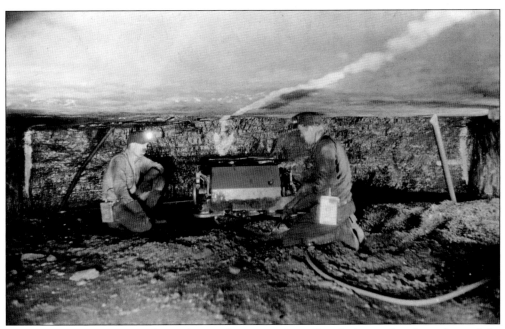

Two coal miners undercut the coal seam for preparation of explosives to break up the coal for loading into mine cars at the Pond Creek mine at Bartley around 1933. The miners each wear cloth hats and early Edison battery lights. Working in low coal seams was not an easy task.

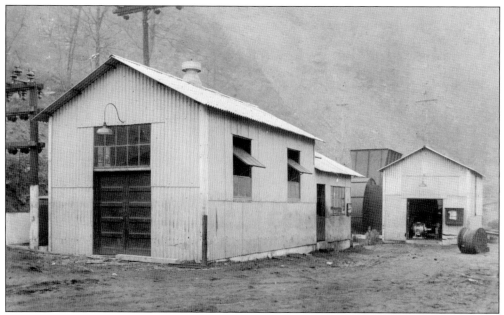

All mines had ventilation systems like the one shown here at Pond Creek Mine at Bartley, West Virginia. This system here has a fan located over a shaft that pulls fresh air through the mines and several other support structures. Fans were usually on a separate electrical source, just in case power was lost inside the mine.

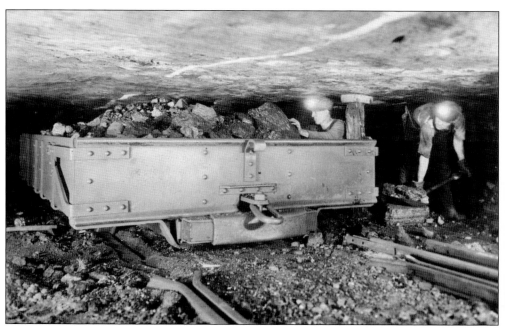

In this view, coal miners load coal into mine cars at the Pond Creek Pocahontas Coal Company. The shovel being used by the miner is a size No. 4 coal shovel. Mine cars like these were coupled together with a link–and–pin system.

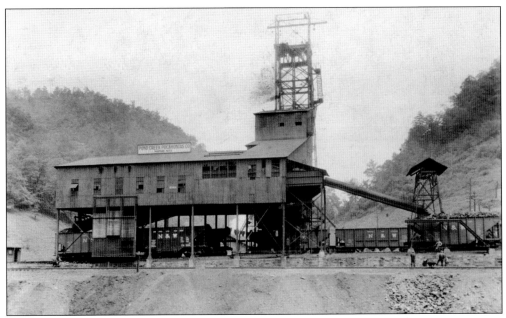

Pictured in this 1933 postcard is the Pond Creek No. 1 mine, which opened in 1924 and operated until 1967. This shaft mine was located on the Dry Fork River and had a mine office in Raysal, West Virginia. The community of Raysal was next to the town of Bradshaw.

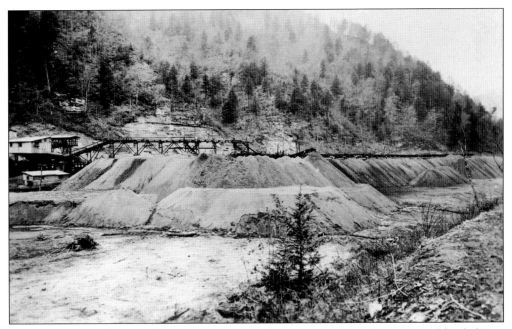

Waste produced after the cleaning of coal was dumped at separate locations and loaded into dump trucks to be used for fill on roads or left in a permanent designated area. This view is of the Pond Creek No. 4 tipple and the Dry Fork River.

This is a double postcard of the United States Coal and Coke Company No. 8 operation at Elbert, West Virginia. Some of the railroad cars are for loading coke. With 172 coke ovens, the company processed over 600,000 tons of coke during its length of operation. The making of coke from burning coal in beehive-type ovens was shipped to plants for the making of steel. In

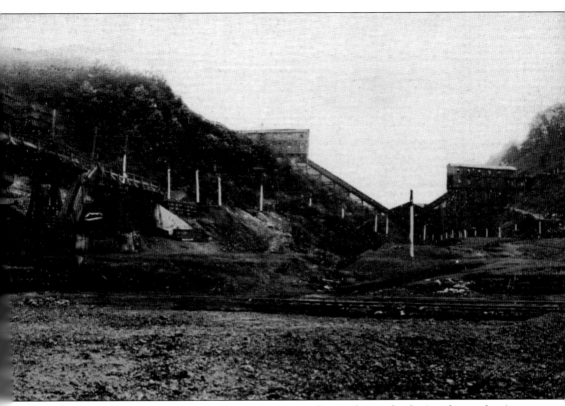

the early years of coke operations, the by-products were lost in the smoke during the production of burning coal, but was later changed and captured. The by-products were used in the making of many things, such as varnish, paints, roofing, solvents, soda water, plastics, dyes, wallpaper, airplane fuel, graphite, medicine, perfumes, and photography.

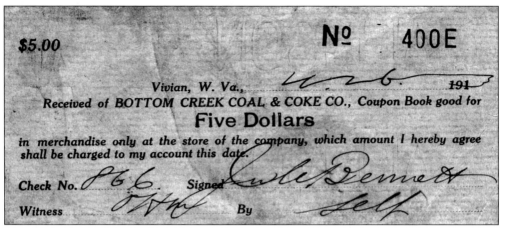

This original $5 scrip book cover from the Bottom Creek Coal and Coke Company at Vivian, West Virginia, is dated 1913. This coupon book would have had tear-out coupons for $1.00, 50¢, 25¢, 10¢, and 5¢. All books would be assigned to a particular coal miner for use at the coal company store. A coal miner and his family could obtain food, clothing, medicine, and furniture at the store.

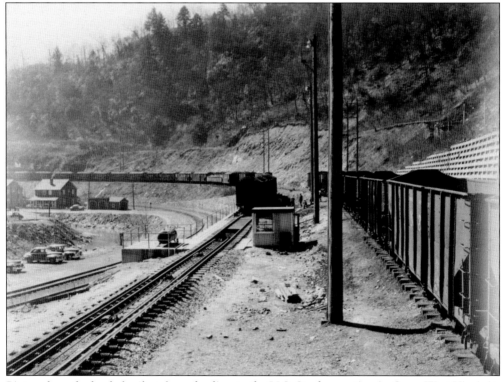

Pictured are the loaded railroad cars leading to the U.S. Steel operation in Gary, West Virginia. These railroad cars came from several U.S. Steel mines a few miles away to be dumped and mixed with other mined coal. The mixing of coal was for a desired effect for the production of coke, for a standard size and of a chemical content.

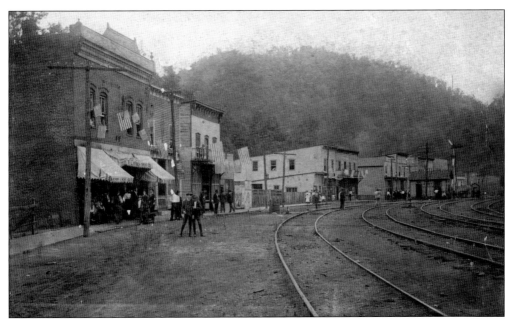

This image, captured in Kimball, West Virginia, on July 4, 1919, shows four railroad tracks on Main Street. In the right side of the photograph is the Norfolk & Western passenger station with West Vivian on the side of the building. Kimball was originally called West Vivian. Kimball was a storage and distribution point for petroleum products as well as a coal yard.

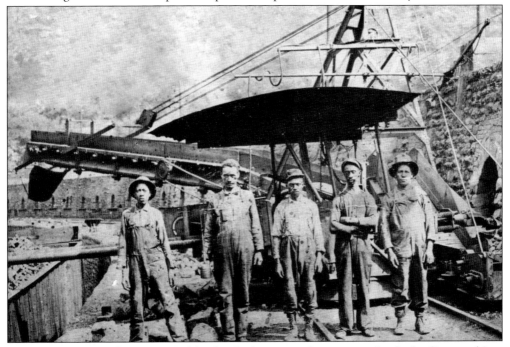

This close-up view shows a typical bank of coke ovens, the automated coke loading machine, and railroad coke cars at an undisclosed location in McDowell County. Tending to the coke ovens was a very dirty and hot job, as evidenced by these hardworking men. Coke was used for making steel because it would burn hotter than coal.

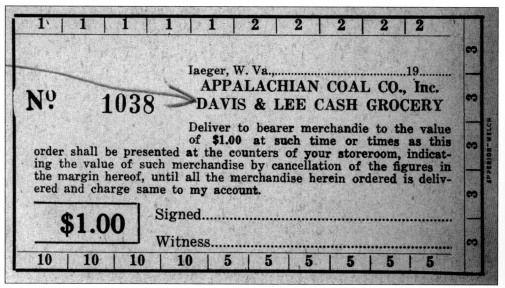

1	1	1	1	1	2	2	2	2	2

Iaeger, W. Va.,..........................19.........

NO 1023

BUFFALO COAL COMPANY
DAVIS & LEE CASH GROCERY

Deliver to bearer merchandie to the value of $4.00 at such time or times as this order shall be presented at the counters of your storeroom, indicating the value of such merchandise by cancellation of the figures in the margin hereof, until all the merchandise herein ordered is delivered and charge same to my account.

$4.00

Signed..

Witness...

75	50	50	25	25	25	25	20	20	15	10	10	10

Not all coal companies used metal scrip; some used paper tear-out books or punch-out card systems. The Buffalo Coal Company, along with Davis and Lee Cash Grocery in Iaeger, West Virginia, used a punch-out card. This $4 card would have been spent buying merchandise and household necessities at the store.

1	1	1	1	1	2	2	2	2	2

Iaeger, W. Va.,..........................19.........

NO 1038

APPALACHIAN COAL CO., Inc.
DAVIS & LEE CASH GROCERY

Deliver to bearer merchandie to the value of $1.00 at such time or times as this order shall be presented at the counters of your storeroom, indicating the value of such merchandise by cancellation of the figures in the margin hereof, until all the merchandise herein ordered is delivered and charge same to my account.

$1.00

Signed..

Witness...

10	10	10	10	5	5	5	5	5	5

Another coal company using paper scrip was the Appalachian Coal Company, also along with Davis and Lee Cash Grocery in Iaeger, West Virginia. Shown here is a $1 card, but $3, $5, and $10 cards were also available. Cards like these would have been used in the 1940s and early 1950s.

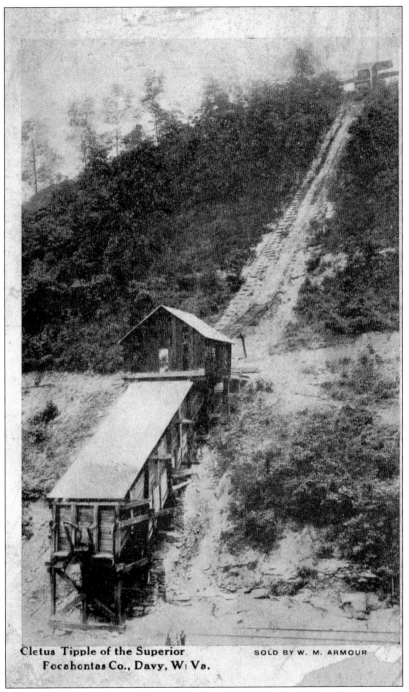

Cletus Tipple of the Superior
Pocahontas Co., Davy, W. Va. SOLD BY W. M. ARMOUR

The Cletus tipple of the Superior Pocahontas Coal Company in Davy, West Virginia, is pictured in this original postcard dated September 22, 1910. This company started mining coal in 1901. Workers mined one of the thin seams of Pocahontas coal, which averaged around three feet high. The mine was sold after three years to the Blackstone Mining Company in Davy. The mine was served by an incline above the tipple, bringing coal down to the mountainside by cable and mine cars to the operation.

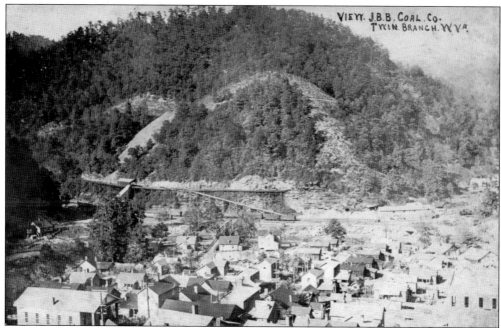

This is a bird's-eye view of the J.B.B. Coal Company in Twin Branch, West Virginia. Twin Branch was about two miles from the town of Davy, West Virginia. The initials J.B.B. stood for Jewett, Bigelow, and Brooks. The mine started operation in 1911 and ended around 1921. There were six mining operations under the name of J.B.B. Coal Company. (Courtesy of Bob McGovern.)

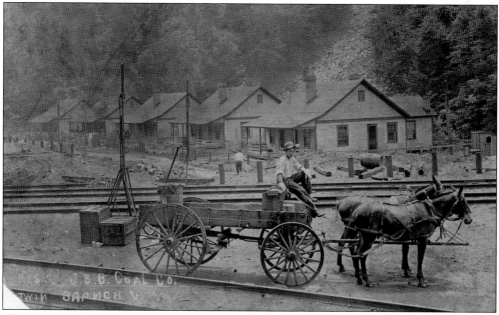

Shown here is part of the mining community of J.B.B. Coal Company at Twin Branch. The team and wagon are sitting close to the Norfolk & Western Railway station and the double-track mainline. The two metal structures standing are the mail cranes, where mailbags were tied upon for the passenger train to pickup as it passed. This early scene is dated January 1, 1914.

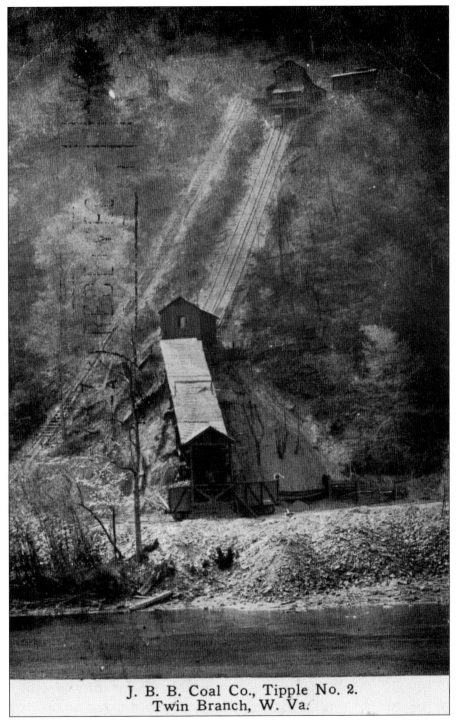

J. B. B. Coal Co., Tipple No. 2.
Twin Branch, W. Va.

The J.B.B. Coal Company tipple No. 2 is pictured here in this original postcard dated March 6, 1912. The No. 2 mine was originally the Flourney Coal Company. Henry Ford bought the property around 1923 and started the Fordson Coal Company, which lasted until 1933. The mine was on the banks of the Tug River.

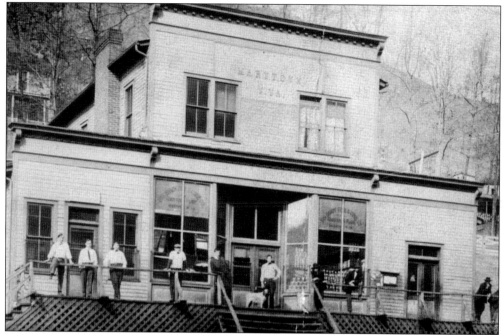

The Big Sandy Coal and Coke Company store shown here is in Marytown, West Virginia. The store was about one mile from Twin Branch. Most coal company stores were of a two-story design and usually had a railroad siding. This coal company started its operation in 1900. In 1910, the name was changed to the Solvay Collieries Company, then later to the Kingston Pocahontas Coal Company.

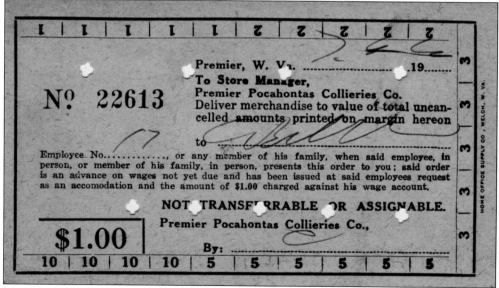

This paper scrip card was issued and used at the Premier Pocahontas Collieries Company in Premier, West Virginia. As with all of these type of cards, they came in different denominations. This mine was on the Spice Creek branch of the Norfolk & Western Railway. Premier started its operations in 1907.

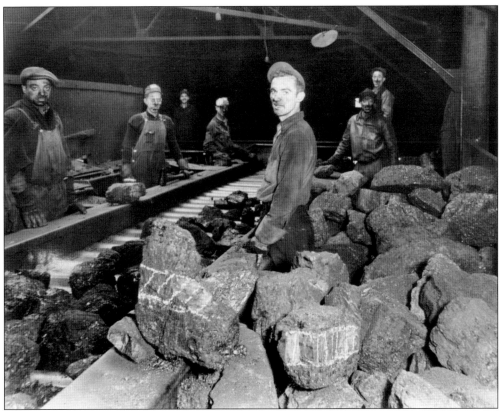

Most of the early coal companies had handpicking tables inside of the tipples for processing coals into different sizes. Heating and cooling the work areas in the tipples was very difficult. Any coal with slate was removed and placed to the side for further processing and loading.

This is the Pocahontas Fuel Companies Norfolk Angle Colliery operation in Maybeury. It was originally owned by the Norfolk Coal and Coke Company. The operation started mining coal in 1888. This mining complex can be seen operating during the 1950s in a DVD called *Pocahontas Glory Vol. 4*.

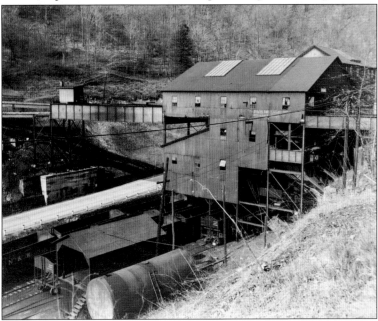

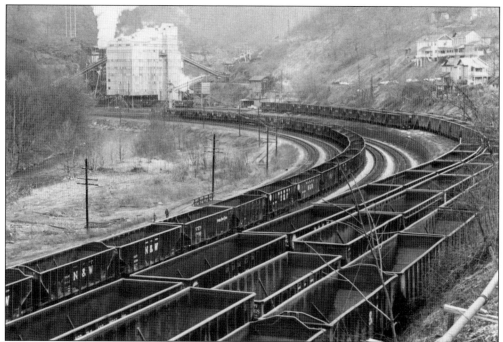

This original photograph shows the Allied Chemical Shannon Branch mine at Capels, West Virginia, in the 1970s. Starting in 1964, Allied Chemical rebuilt the coal-mining plant into a more modern complex and operated until 1980. The operation was along the Norfolk & Western Railway and had a huge capacity for loads and empty railroad hopper cars.

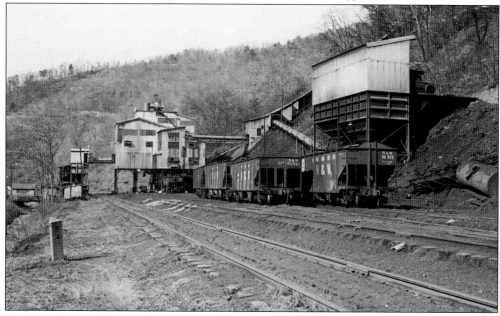

The Royalty Smokeless Coal Company tipple in this original photograph is from the 1970s. This operation was located next to the community of Premier, West Virginia, on the Spice Creek branch of the Norfolk & Western Railway. Royalty Smokeless operated from 1956 to 1987, and the coal's marketing brand name was Red Robin Pocahontas.

| 1 | 1 | 1 | 1 | 1 | 2 | 2 | 2 | 2 | 2 |

Nᵒ 27893 War, W. Va._____19____

Susanna Pocahontas Coal Co.

Deliver to bearer merchandise to the value
of **$1.00** at such time or times as this
order shall be presented at the counters of your storeroom, indicat-
ing the value of such merchandise, by cancellation of the figures in
the margin hereof, until all the merchandise herein ordered is deliv-
ered and charge same to my account.

$1.00 Signed _____

Witness _____

| 10 | 10 | 10 | 10 | 5 | 5 | 5 | 5 | 5 | 5 |

This punch-out scrip card is from the Susanna Pocahontas Coal Company and was issued on February 29, 1940. The Susanna mine began mining in 1932 and ceased production in 1936. They mined the War Creek coal seam. The city of War was only 1.5 miles from the mine site.

| 1 | 1 | 1 | 2 | 2 | 3 | 5 | 5 | 5 | 5 | 5 | 5 | 10 | 10 | 10 | 10 | 10 | 10 |

Nᵒ 583 Davy, W. Va._____194____

DeHART COAL COMPANY

Deliver to bearer merchandise to the value
of **$10.00** at such time or times as this
order shall be presented at the counters of your storeroom, indicat-
ing the value of such merchandise by cancellation of the figures in
the margin hereof, until all the merchandise herein ordered is deliv-
ered and charge same to my account.

$10.00 Signed_____

Witness_____

| 1.00 | 1.00 | 1.00 | 50 | 50 | 50 | 50 | 50 | 50 | 50 | 50 | 50 |

This $10 scrip card is from the DeHart Coal Company, located in Davy, West Virginia, and is unused. Most of these scrip cards were printed by Superior Office Supply Company in Welch. The DeHart Coal Company operated in the 1940s. Documents from the early coal years usually did not survive.

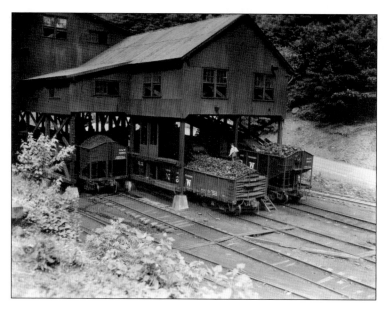

The Mill Creek Coal and Coke Company tipple pictured in the original photograph was in Barlow Hollow next to Maybeury, West Virginia. Some of the coal processed here was from the Tug branch side of the mountain. A mine tunnel was constructed out of brick to reach the coal. The date of this photograph is around 1940.

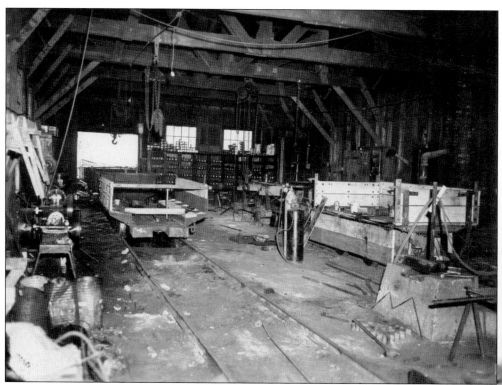

This interior view of a mine shop at Mill Creek Coal and Coke Company is showing repair work being done on mine cars. In this original 1940 photograph, the two mine cars' wood sides are being replaced. The machine shop is well equipped to handle any repair. This operation worked until 1944.

The scale office at the Mill Creek Coal and Coke Company in July 1940 shows two men keeping track of the mine cars as they were weighed. The mine cars were tagged with a miner's metal check, made out of brass with his number on it. Coal miners were paid according to how many tons were loaded.

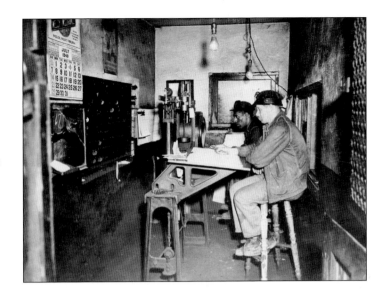

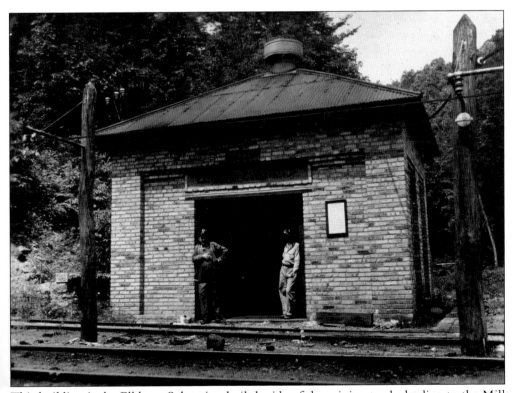

This building is the Elkhorn Substation built beside of the mining tracks leading to the Mill Creek Coal and Coke Company tipple at Maybeury. In this July 1940 photograph, the tracks to the left lead to the brick mine tunnel, which leads to the Tug operation. Part of this building still stands.

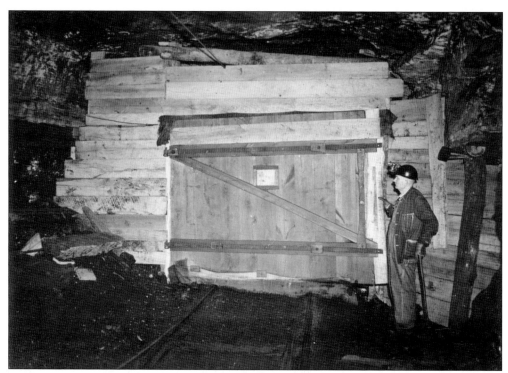

This original mine photograph of a trap door used to divert air to different locations inside the mine is in the Mill Creek Coal and Coke Company. Some of the doors were built of wood, cinder blocks, or braddish cloth. This coal seam is around nine feet high.

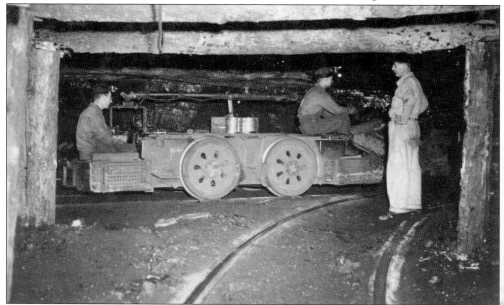

This is an electric mine motor pulls mine cars in and out of the mine. This is another view inside the Mill Creek Coal and Coke Company. Notice the miners' aluminum dinner buckets on top of the electric motor. The miners in this original photograph wear turtle shell hats and use carbide lamps. Carbide lamps used carbide and water to make acetylene gas for light.

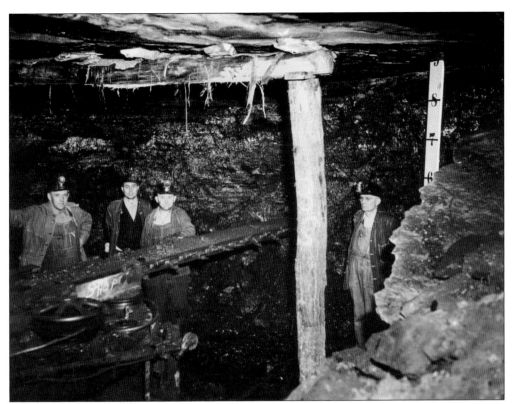

This original photograph shows a mine-cutting machine at the face, where the coal is nine feet high. Miners would undercut the seam across the bottom and then drill holes into the block of coal for explosives. Timbers were used to hold up the top and secure the work area in this interior 1940 view of the Mill Creek Coal and Coke Company mine.

In this original photograph, the coal seam is being prepared for the coal miners to load coal for processing. As mine cars were loaded, their mine checks would be hung on the side. Each miner would get credit for the cars he loaded. This mine location is the Mill Creek Coal and Coke Company in Maybeury.

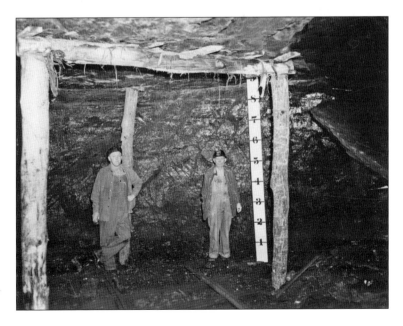

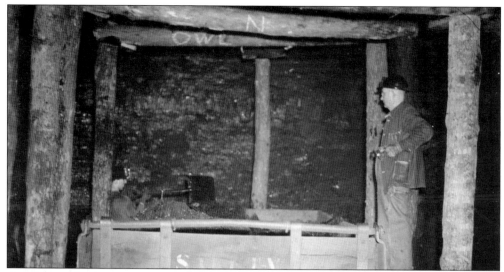

A coal miner loads a mine car with a No. 4 shovel; the number represents the size of the shovel. High coal shovels where usually bent, where straight shovels were used for low coal. Mill Creek Coal and Coke Company was safety conscious by the words "Safety First," printed on the mine car.

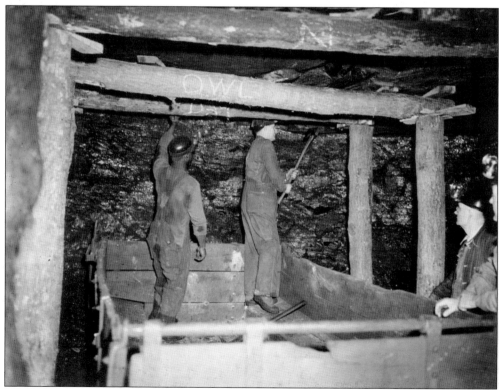

These coal miners work at the face, checking the top for loose rock and slate and installing timbers around the work area. Local sawmills provided wood props, headers, cap boards, wedges, and crib blocks to be used in the mines. This is another view of the Mill Creek Coal and Coke Company mine.

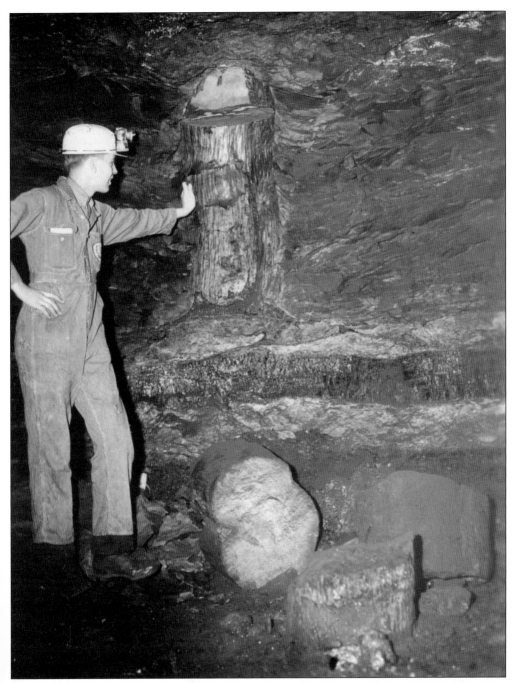

Petrified plants and tree trunks were found throughout all mining operations. This petrified tree trunk, at the Mill Creek Coal and Coke Company mine, shows a large tree trunk imbedded in the coal seam. Some of the petrified tree trunks in the roof of the mine were called "widow makers," because they could dislodge and crush anyone underneath. Coal's beginnings are the remains of plants that grew in swamps 315 million years ago. As the plants decayed in stagnant water, they became peat bogs. Coal is derived from the decay of plant life rather than from clay or sand particles or chemical compounds.

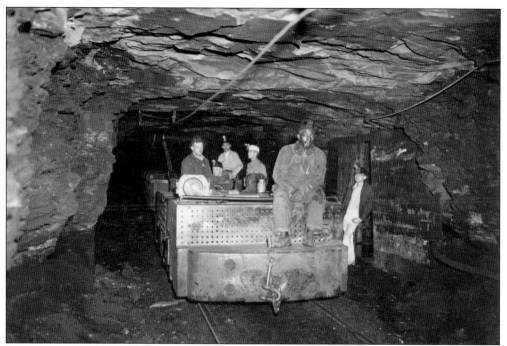

Mine haulage ways were always busy with the loads and returns of empties. As seen here, electric cables were attached to the roof for electric mine motors. Some miners would hitch a ride to another location in the mine. No support is needed here, as the top of the haulage way is solid enough. This is a 1940 view of the Mill Creek Coal and Coke Company mine.

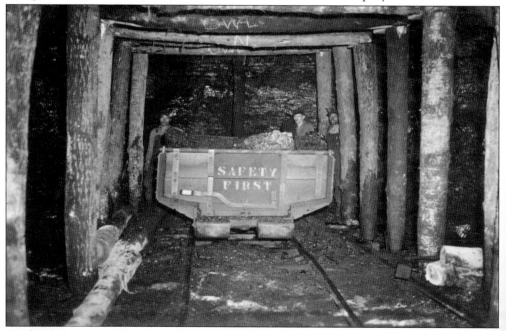

This loaded mine car is being delivered to the Mill Creek tipple. Gathering motors would be brought in to assemble a mine trip to the surface. Sections of mines all had different names; the one here was named the Owl section, based on the wording on the wooden supports.

This appears to be a cutting machine to take down coal in the face of the coal seam. These miners are probably on their lunch break. The timbering on the sides of the mines, known as the "ribs," was to keep the sides from falling in. This c. 1940 scene is from the Mill Creek Coal and Coke Company mine.

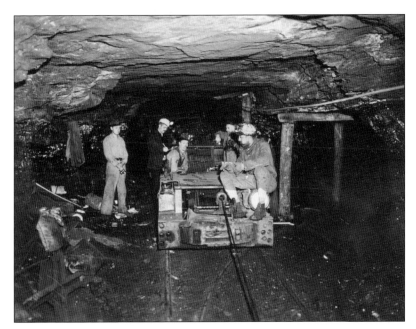

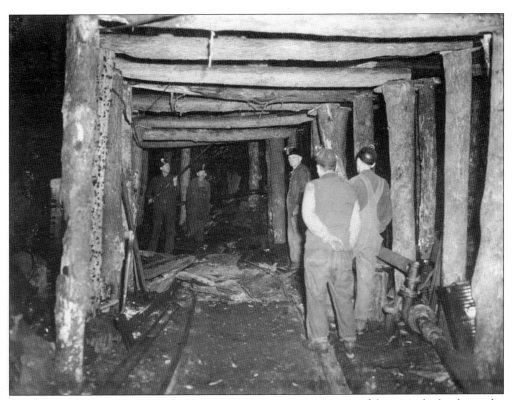

This group of miners installs wood supports in a new section. Some of the props had to be cut by hand with a crosscut saw and one-man two-man saws, which had a regular handle on one end and a peg on the other. Tools like these were used at all coal mines locations, inside and out.

Ink blotters were used by most coal companies, like this one here from the Olga Coal Company in Coalwood, West Virginia. When businesses used quill-type pens to dip into inkwells, they would use the blotter to soak up the excess ink on a document or letter. Ink blotters were also a form of advertising for the coal company.

This $10 coupon book, issued to Ashley's Store Inn & Club House, was used by Norfolk & Western employees in Wilcoe, West Virginia. The clubhouse was located next to the Norfolk & Western Railway Wilcoe yard and about two miles from Gary, West Virginia. They also had a location in Bluefield, West Virginia.

BY-LAWS

JUNIOR POCAHONTAS COAL COMPANY BURIAL FUND

●

Welch, W. Va.

●

As Adopted and Accepted
October 1, 1935

This October 1, 1935, booklet contains the bylaws of the Junior Pocahontas Coal Company (owned by Houston Coal Company) burial fund in Welch, West Virginia. The fund covered burial expenses of deceased employees of the Houston Coal Companies of Welch and their dependants. The benefits, the sum of $50, were distributed to the families of any miner who was accidentally killed in the mines. To qualify, the miner needed to be allowed compensation from the state compensation commission.

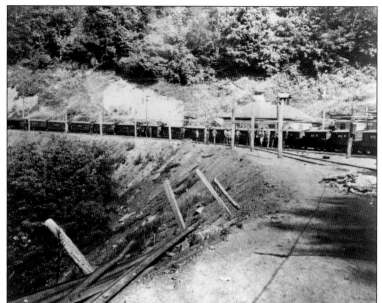

This original photograph is of the Mill Creek Coal and Coke Company's mine cars around 1935. The image was captured at the Tug No. 1 mine at the head of the Tug River near Leckie and Anawalt in West Virginia. The coal mined here is shipped to the coal operation through the mountain to Maybeury.

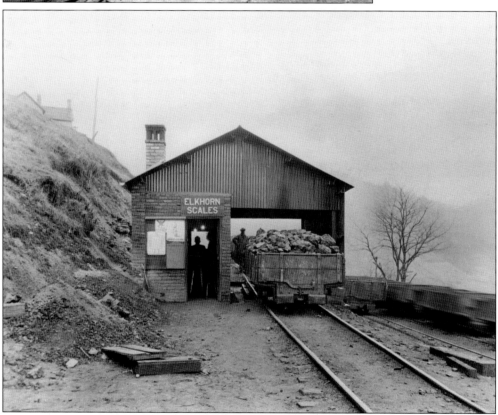

Shown here is the Elkhorn scale house located in Maybeury. All mine cars were weighed here before going to the mine. The mine car loaded here is referred to as a graveyard hump, meaning that the load of coal has a hump in the middle of the mine car. Several safety posters are on the building, and the right side shows a string of empties going back to the mine.

By-Laws

of the

COMMUNITY BENEFIT

ASSOCIATION

of

Superior, W. Va.

EFFECTIVE JULY 1, 1959

SUPERIOR-WELCH H55 D3161

This original booklet of by-laws is that of the Community Benefit Association of Superior, West Virginia; these by-laws have an effective date of July 1, 1959. This booklet was for the employees of the Lake Superior Coal Company. The purpose of the by-laws was to afford benefits in cases of death of members of the association and their dependents. The author's father worked as a motorman at the Lake Superior Coal Company mine for 19 years. The author of this book was born in Superior, West Virginia, in 1949 and lived there until 1963 before moving to Welch, West Virginia.

No............................ ..19..........

Tipple Foreman, Please Deliver to

..

Lump.....................

Egg........................

Stove..................... ALGOMA C. & C. CO.

Nut........................

R. O. M................. By..

SUPERIOR-WELCH

JAN 1950 WST

This is an original coal order form that would be sent to the Algoma Coal and Coke Company's tipple foreman, for coal to be delivered to a coal miner; it is dated January 1950. The miner usually bought house coal for heating and use in cooking stoves. The order form shows lump, egg, stove, nut, and ROM (run of mine) coal varieties. These requisitions were used quite often during wintertime conditions. The Algoma Coal and Coke Company mine was in Algoma, West Virginia.

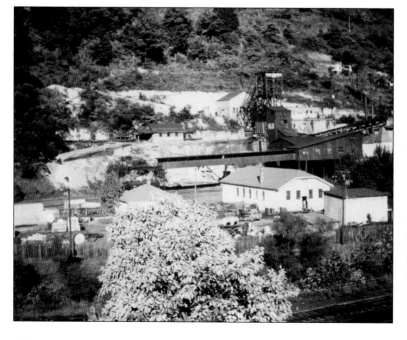

The Lake Superior Coal Company began its operation in 1913. The company was formerly the Dixon Pocahontas Fuel Company. Algoma Steel of Ontario, Canada, controlled the mine here and shipped the coal across Lake Superior. Algoma Steel also owned Cannelton Coal and Coke of Cannelton, West Virginia.

This 1920s view of Lake Superior Coal Company shows four loadout tracks and one to receive empties. Railroad cars were pushed passed the tipple to a storage siding and dropped back through the tipple by gravity. The row of houses in the background, called "Good Husband Row," was situated along Elkhorn Creek.

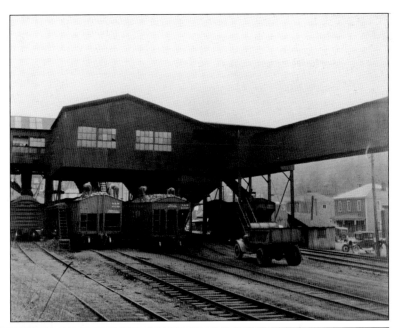

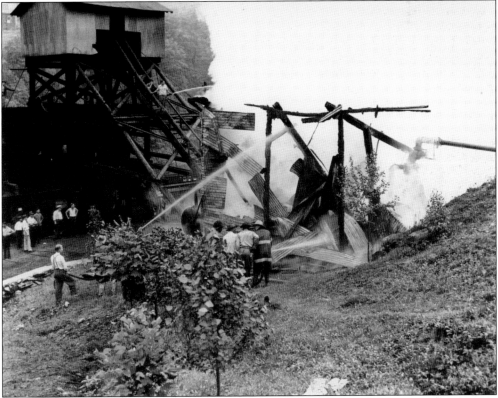

The hoist house here was destroyed by fire at the Lake Superior Coal Company in June 1946. The fire was caused by a lightning strike during a summertime storm. This is the No. 4 mine, located below US route 52 and above the company store. The hoist house brought the cage up and down in the mine shaft.

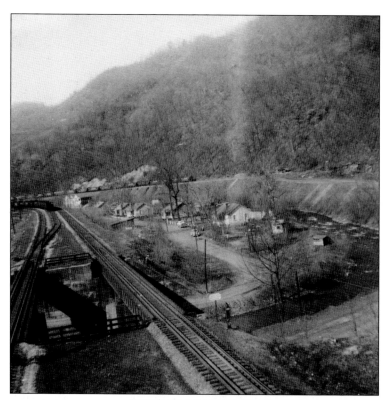

The coal community of Stringtown in Superior, West Virginia, is seen in this photograph, taken in March 1962. The first house is where the author grew up and enjoyed playing and riding bicycles. Superior was originally called Huger. The fourth house is where the Vass family lived. (Courtesy of the Margaret Vass family.)

Pictured on Christmas Day 1959, from left to right, are Don Vass (nine years old), Jay Chatman (the author at nine years old), and Blair Vass (six years old) with brand new bicycles bought at the coal company store (or rather, Santa). Coal camp life was simple, but almost everyone had the grandest of times and memories of the best Christmases in a coal community. Shown here is the neighborhood crew. (Courtesy of the Margaret Vass family.)

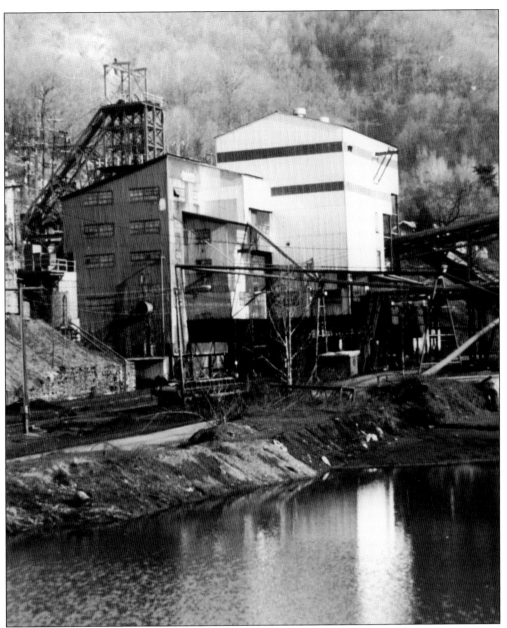

Lake Superior Coal Company name was changed to Cannelton Coal Company in 1959. In this 1980s photograph, the road passing beneath the tipple is old US Route 52. In 1973, Cannelton Coal Company became Cannelton Industries. The water in the foreground is a settling pond for coal waste. The original bullwheels and super structure over the shaft are still in place. Deep-shaft mining is no longer being used here.

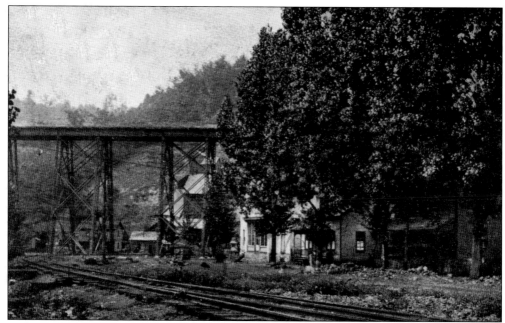

This postcard view of the Shamokin Coal and Coke in Maybeury is dated October 11, 1912. The Shamokin mining operation began January 1, 1889, and continued until 1903. The company was merged into the Pocahontas Consolidated Company in 1904. Jenkin Jones, an early coal pioneer, was general manager of the Pocahontas Consolidated Company and had his home in Bramwell, West Virginia. (Courtesy of Lacy Wright Jr.)

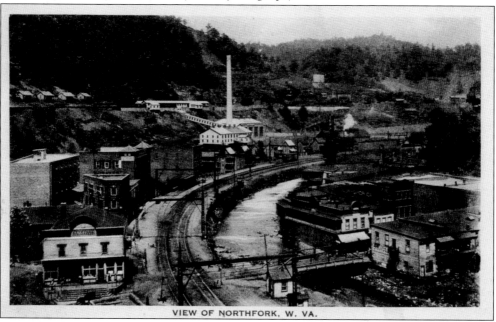

VIEW OF NORTHFORK, W. VA.

Shown here is the Keystone Coal and Coke Company in Keystone, West Virginia. The town of Keystone, the coal-mining plant, and Norfolk & Western Railway are in this view. The Keystone Coal and Coke Company started its operation in July 1890. The postcard incorrectly identifies the town as Northfork. (Courtesy of Lacy Wright Jr.)

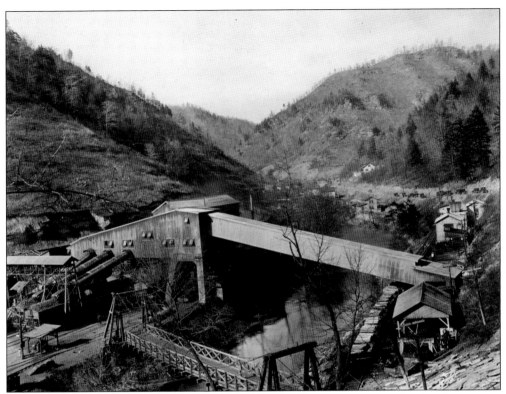

This original photograph is of the Pond Creek Pocahontas Company No. 3 operation next to Bartley, West Virginia. It was built along the Dry Fork River and mined the War Creek seam. The company promoted its coal as "4 Point Coal." The mines operated from 1930 to around 1959.

This is the office for the Pond Creek Pocahontas Company in Bartley, West Virginia. An explosion took place in Bartley on January 19, 1940, killing 91 miners. A monument was erected in Bartley for the mine disaster, located on West Virginia Route 83 in McDowell County. (Courtesy of Norfolk & Western Railway)

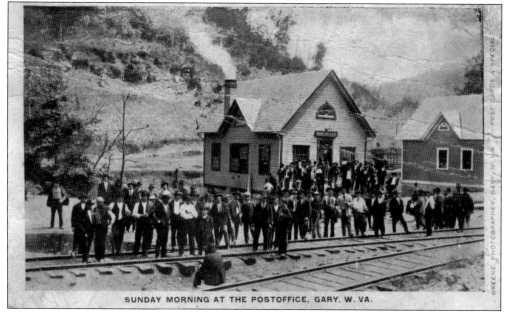

SUNDAY MORNING AT THE POSTOFFICE, GARY, W. VA.

This image was captured during a Sunday morning at the post office in Gary, West Virginia. The United States Coal and Coke Company had several operations in and around Gary. In the background is part of the United States Coal and Coke No. 3 operation, which was designed to be a coke plant. This original postcard is postmarked March 12, 1908.

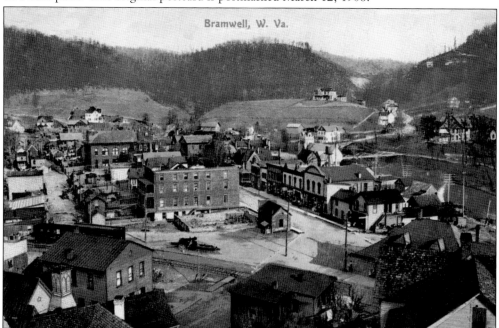

Bramwell, W. Va.

The town of Bramwell is seen in this dated postcard August 6, 1909. The town was established around 1885 because of early coal developments. Many of the early coal operators, who owned mines in McDowell County, had their headquarters here. Some of the mines were those of Mill Creek Coal and Coke in Maybeury and the Cherokee Colliery Company mine close to Ashland, West Virginia.

Three

RAILROADING ON THE POCAHONTAS DIVISION

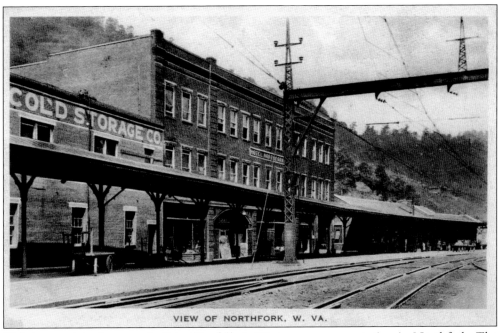

VIEW OF NORTHFORK, W. VA.

This is an original postcard of the Norfolk & Western passenger station in Northfork. The railroad ran through the town and was part of the Pocahontas Division. In 1913, the Norfolk & Western Railway electrified this division from Auville Yard in Iaeger to Bluefield, West Virginia. The power plant was built to supply current at Bluestone, West Virginia. (Courtesy of Lacy Wright Jr.)

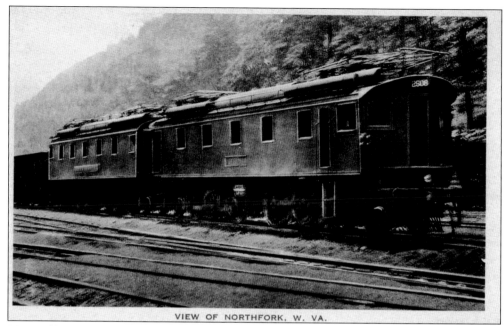

Pictured here are the No. 2508 Norfolk & Western LC-1 electric engines in Northfork. These were operated in pairs and were semipermanently attached together. The LC-1 electrics were built by the Baldwin Locomotive Works and Westinghouse between December 1914 and 1915 and numbered 2500 through 2511.

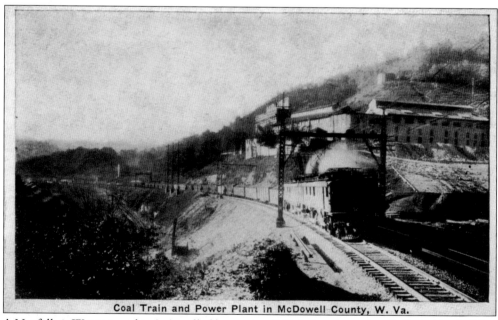

Coal Train and Power Plant in McDowell County, W. Va.

A Norfolk & Western coal train is pulled by a pair of LC-1 electric engines in Switchback, West Virginia. The Switchback community is beside Maybeury. Two coal-mining companies located here were the Delta and Lick Branch Collieries of the Norfolk Coal and Coke Company. The power plant on the hill was built by the Pocahontas Consolidated Collieries Company.

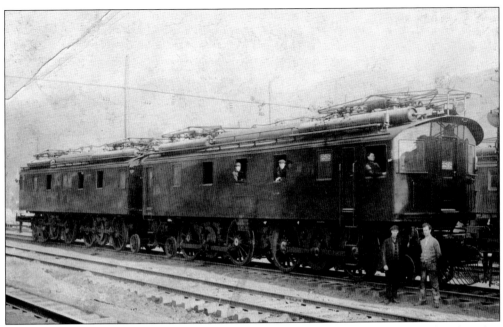

This undated real-photo postcard is of No. 2506 LC-1 electric engine in the railroad yard at Keystone. These electric engines had speeds of 14 and 28 miles per hour. The LC-1 engines could handle 1,625 tons with a maximum horsepower of 3,211. They were also referred to as boxcabs.

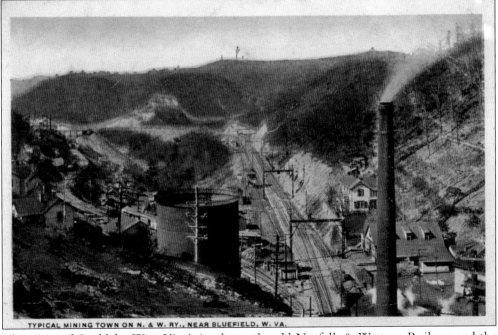

TYPICAL MINING TOWN ON N. & W. RY., NEAR BLUEFIELD, W. VA.

This view of Coaldale, West Virginia, shows the old Norfolk & Western Railway and the Coaldale Coal and Coke Company to the left. Beneath the smokestack is the Coaldale single-track tunnel. Maybeury was three miles downgrade from this location. The railroad tracks were changed in 1949 and 1950 to ease the grade from 2 percent to 1.4 percent.

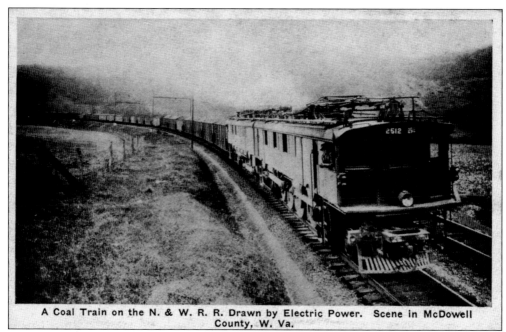

A Coal Train on the N. & W. R. R. Drawn by Electric Power. Scene in McDowell County, W. Va.

In this postcard scene is No. 2512 LC-2 electric engine. No. 2512 is the class unit for this series. There were only eight units built in 1924, and they were Nos. 2512 to 2515. The cab of the LC-2s had two jackshafts, each driven by one large motor.

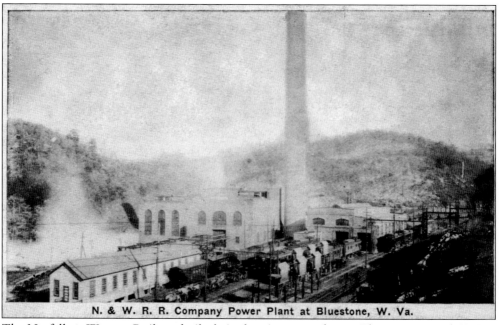

N. & W. R. R. Company Power Plant at Bluestone, W. Va.

The Norfolk & Western Railway built their electric power plant at Bluestone around 1915 to supply 11,000 volts, 25-cycle alternating current for its LC-1 and LC-2 electric engines, which operated in McDowell County. Norfolk & Western's electrification was scrapped in 1950 after the realignment of the tracks at a different grade.

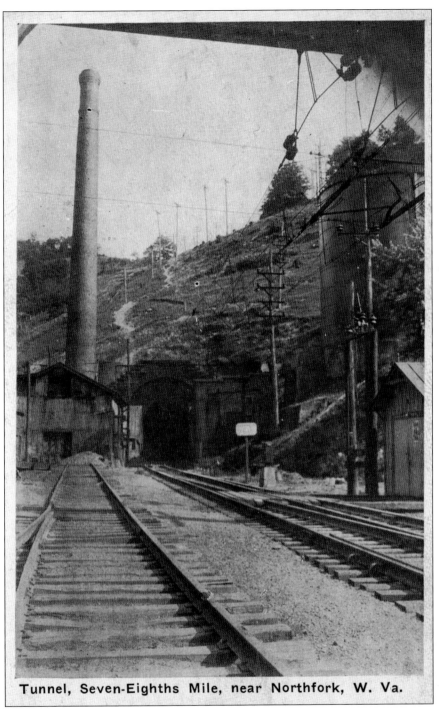

Tunnel, Seven-Eighths Mile, near Northfork, W. Va.

The Norfolk & Western Coaldale Tunnel had a single track going through to Coopers toward Bluestone, West Virginia. This shows the catenary system for the LC-1 and LC-2 electric engines that ran in McDowell County. The railroad had a station here with a large water tank on the hill. John Cooper and Company of Bramwell owned the Coaldale Coal and Coke Company that operated here.

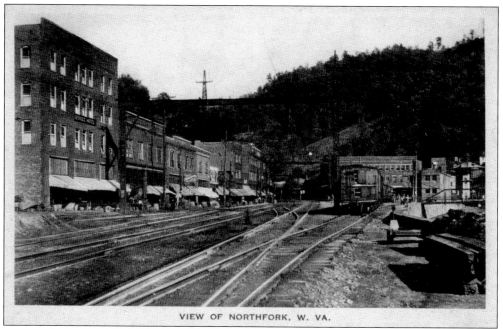

VIEW OF NORTHFORK, W. VA.

Looking toward Kyle, this postcard view of the Norfolk & Western mainline in Northfork was taken around 1922. The town looks very busy along this railroad line. The Georges Hotel, Armour Meat Packing Plant, and the railroad passenger station can be seen here along with many other businesses. A Norfolk & Western refrigerator car has been spotted on the siding.

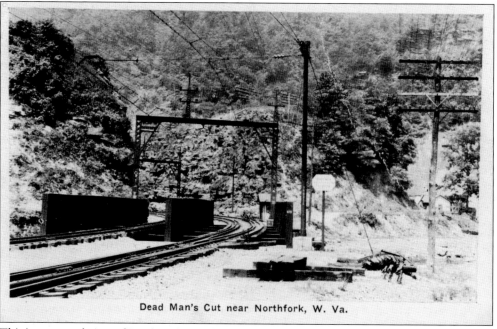

Dead Man's Cut near Northfork, W. Va.

This is a postcard view of Deadman's Cut, located between Keystone and Northfork. The Norfolk & Western bridges cross the Elkhorn Creek here. The Deadman's Cut was named because of the unfortunate ones who were found there on occasion due to fights at local saloons or gambling houses, there were several saloons in both Keystone and Northfork.

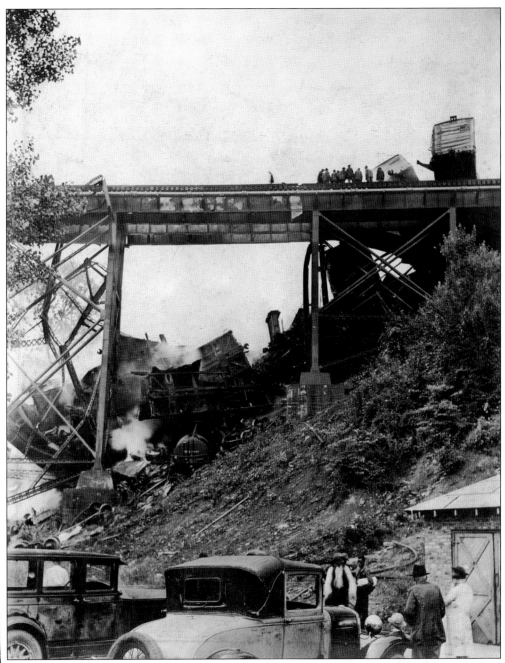

This photograph is of the Norfolk & Western Railway's time freight train No. 85 that wrecked at Maybeury on June 30, 1937. Over 40 railcars and the steam engine No. 2037 jumped the high trestle bridge and crashed on to the road below. The engineer, fireman, brakeman, and a bystander were killed. The wreck left a 39-foot-wide hole in the highway below, and the bridge was damaged by a raging fire.

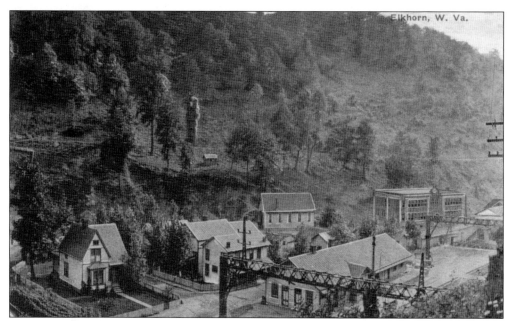

This 1920s image, titled Crozer Land Association, was captured at Elkhorn, West Virginia. The Crozer Land had its headquarters at this location for many years. Shown here are the Elkhorn Graded School, a Norfolk & Western passenger station, and a church. At one time, Elkhorn was the terminus for the Norfolk & Western Railway until the Ohio Extension was built, stretching toward Welch.

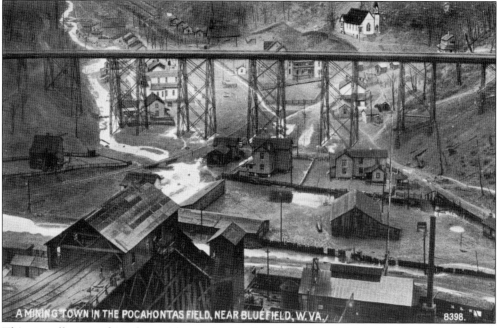

This overall view of Maybeury shows the Norfolk & Western high bridge looking from the Shamokin Coal and Coke Company mine. Elkhorn Creek is seen on the left, flowing through the community toward Switchback. This bridge is where the 1937 train wreck occurred on the right side.

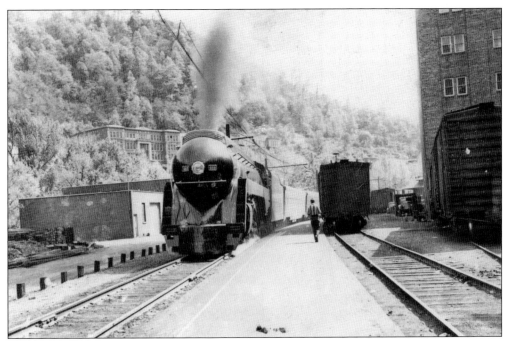

Norfolk & Westerns J-class steam engine No. 603 is shown here leaving the Welch passenger station. This passenger train is the Norfolk & Western's Powhatan Arrow, which ran from Cincinnati, Ohio to Norfolk, Virginia. Welch High School is in the background on the hill, and Elkhorn Valley Grocery Company building is to the right.

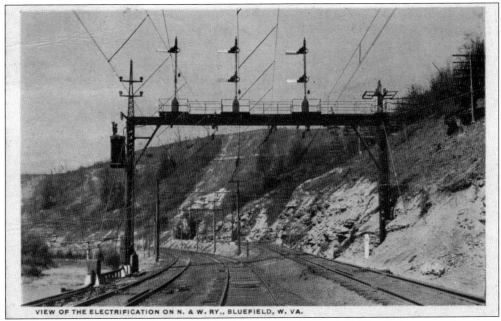

VIEW OF THE ELECTRIFICATION ON N. & W. RY., BLUEFIELD, W. VA.

This early postcard image offers a close look at the catenary system, which the Norfolk & Western Railway used from Iaeger to Bluefield for its electric engines. This was busy mainline for coal traffic from McDowell County. The catenary system was dismantled in 1950. Steam engines were still used on the 1.4-percent grade until 1959.

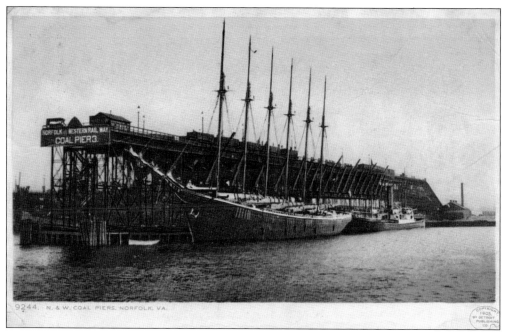

Coal piers were built in Norfolk, Virginia, to load coal on ships to be distributed on the coastline of the Eastern United States and foreign ports by the Norfolk & Western Railroad. The railroad cars were cradle dumped into electric railroad cars that traveled to an elevator system. Once they reached the top, they ran out onto a pier to dump coal into waiting ships. This is Coal Pier 3.

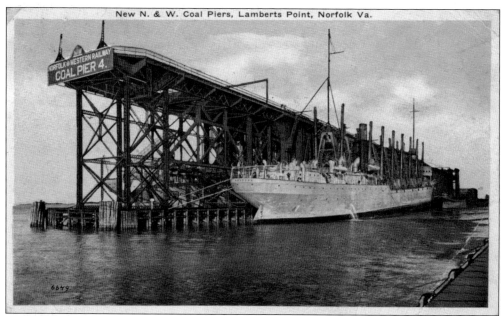

This is a view of Coal Pier 4 of the Norfolk & Western Railway with the same system for shipments of coal by ship as described above. Ships had to be moved back and forth to equally distribute the load of coal. The ship pictured here is of steam design. Several piers were built over the years. This original postcard is dated November 1921.

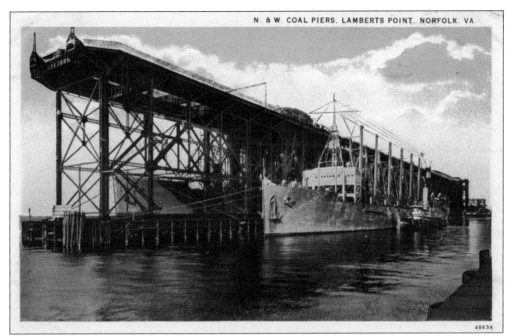

48634

This postcard, dated August 22, 1930, is showing the Norfolk & Western coal pier at Lamberts Point in Norfolk. Ships are being loaded with Pocahontas coal from both sides. Most coal mined in McDowell County was shipped to Lamberts Point, where coal was distributed over seas and to homeports located along the East Coast.

N. & W. TUNNEL, BLUESTONE, W. VA.

This is the Norfolk & Western tunnel at Bluestone that leads through to Cooper Tunnel and Coaldale Tunnel in McDowell County. Bluestone was the junction for the Bluestone branch line with the main line. Building tunnels in these rugged mountains was a difficult job, but they were necessary to reach the rich coalfields.

N&W Dam, Bluestone, W. Va.

In this October 8, 1908, original postcard is the Norfolk & Western dam on the Bluestone River in Bluestone, West Virginia. This is where the railroad had its electric power plant for its LC-1 and LC-2 electric engines. The river here offered the Norfolk & Western Railway several uses for the water.

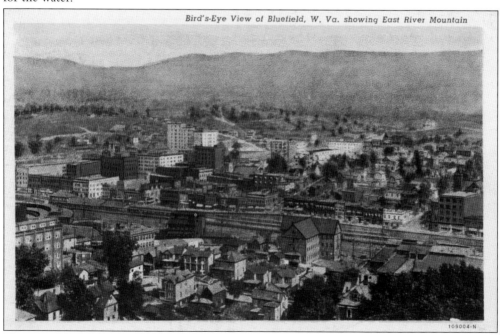

Bird's-Eye View of Bluefield, W. Va. showing East River Mountain

This bird's-eye view of Bluefield shows East River Mountain and the Norfolk & Western Railway yard. The tracks to the right lead to the Elkhorn extension into McDowell County to serve many coal mines operating there. The coal trains entering the yard from McDowell County were handled here before moving on to Roanoke, Virginia.

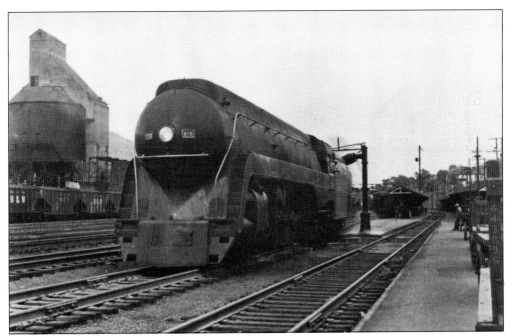

Sitting at the Bluefield passenger station is the J-class steam engine No. 610 with its westbound Powhatan Arrow passenger train. Within 30 minutes of departure, it would enter McDowell County, traveling through towns of Northfork, Keystone, and Kimball, with a stop in Welch, West Virginia. This postcard is dated May 1957.

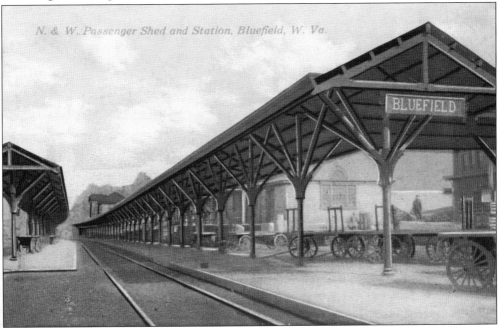

This is the long passenger canopy at the Norfolk & Western passenger station in Bluefield. This station was of a brick design, as was the one in Welch. Passengers departing here could go east to Roanoke, Virginia, or west toward Welch. The Norfolk & Western Railway discontinued passenger trains in 1971, when Amtrak took over the routes.

Discover Thousands of Local History Books
Featuring Millions of Vintage Images

Arcadia Publishing, the leading local history publisher in the United States, is committed to making history accessible and meaningful through publishing books that celebrate and preserve the heritage of America's people and places.

Find more books like this at
www.arcadiapublishing.com

Search for your hometown history, your old stomping grounds, and even your favorite sports team.